NEWCASTLE-UNDER-LYME

THROUGH TIME

Neil Collingwood &
Gregor Shufflebotham

AMBERLEY PUBLISHING

Acknowledgements

The authors would like to thank Marjorie Colville for allowing us to reproduce some of her late husband Bill's collection here. We would also like to thank Robert Foster, Delyth Copp, Teresa Mason, Beryl Carter and Stan Mayer of Newcastle-under-Lyme Borough Museum for their assistance and encouragement. Thanks also to Sue and Anne Fox, Mr B. J. Fradley, Graham Bebbington and Charlie Middleton. We have tried to track down the copyright owners of all photographs used and apologise to anyone who has not been mentioned.

This book is dedicated to the late William (Bill) Colville of Seabridge Road who was known personally to both authors and whose collection of photographs, some taken by himself and some by others, played a vital role in the this compilation.

First published 2012

Amberley Publishing
The Hill, Stroud
Gloucestershire, GL5 4EP

www.amberley-books.com

Copyright © Neil Collingwood &
Gregor Shufflebotham, 2012

The right of Neil Collingwood & Gregor
Shufflebotham to be identified as the Authors of
this work has been asserted in accordance with the
Copyrights, Designs and Patents Act 1988.

ISBN 978 1 84868 306 8

British Library Cataloguing in Publication Data.
A catalogue record for this book is available from
the British Library.

Typeset in 9.5pt on 12pt Celeste.
Typesetting by Amberley Publishing.
Printed in the UK.

Introduction

The 'ancient and loyal' Borough of Newcastle-under-Lyme is located in the extreme north-west corner of Staffordshire and the Borough itself has boundaries with both Shropshire (around Loggerheads) and Cheshire (at Betley). The original Borough, with its elected officials, seems to have come into existence in 1173 when a Charter was granted to it by Henry II, and the octocentenary of this charter was enthusiastically celebrated in 1973. The Borough in those early times was relatively small and up until the nineteenth century consisted mainly of the town and its seven surrounding common fields: Ashfield, Brampton Field, Clayton Field, Kingsfield, Poolfield, Stonyfield and Stubbsfield, the names of which all still survive in modern Newcastle. From around 1901 onwards other settlements were incorporated into the Borough with the largest change occurring in 1932 when Wolstanton, Chesterton, Silverdale, and parts of Clayton, Audley and Keele were absorbed into the Borough, increasing its area to 8,832 acres.

Although not a Borough until 1173 the settlement was certainly in existence before then and both the name Newcastle-under-Lyme and the settlement almost certainly came to exist towards the middle of the twelfth century when a new castle was erected at the fork of major roads linking London with Carlisle and Chester. This wooden castle and its associated township were first mentioned in documents in 1149, probably shortly after its construction. Because the castle and the town were not in existence until the twelfth century, the settlement is not to be found in William the Conqueror's Domesday Survey completed in 1086, although some local historians believe that people were already settled there then but were simply included under other settlements such as Trentham. Recognisable settlements in the Borough that did appear in the Domesday Book include Knutton, (Clotone) Wolstanton, (Wlstanetone) Clayton (Claitone) and Dimsdale (Dvlmesdene) amongst others.

Historically, Newcastle's industries were mainly of an extractive nature, such as coal and ironstone mining, and a number of pre-eminent families in the area such as the Sneyds of Bradwell and Keele Halls made large fortunes from these. Other important industries were the interlinked felt-making and millinery trades which survived for centuries until the middle of the nineteenth century when both died out quite quickly. In the 1800s felt bodies made in Newcastle were sent to London for finishing into the fashionable hats of the day and large numbers of fur caps were made there, many of which were exported to America. Men such as James Astley Hall, who presented the present portico, clock-tower and clock to the town in 1861, made significant sums of money from hat-making.

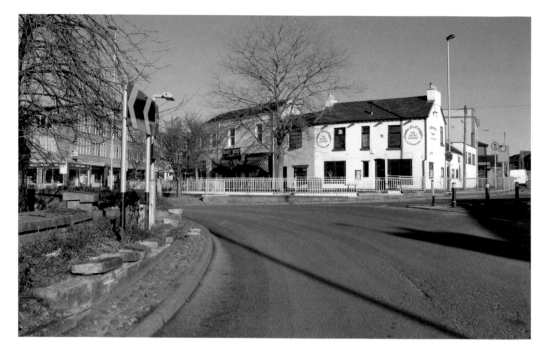

Junction of London Road and High Street, 1950s

In this 1950s photograph the Magnet Café has opened but the Antelope has closed and become shops. The High Street is visible from the Spread Eagle to the Market Hall with the Guildhall beyond. The end of Stubbs Street, now almost exclusively used by buses, can be seen on the right. The parked vehicles are about five metres above where the gardens in the 'sunken roundabout' are located today and photography from here is only safe on a Sunday morning.

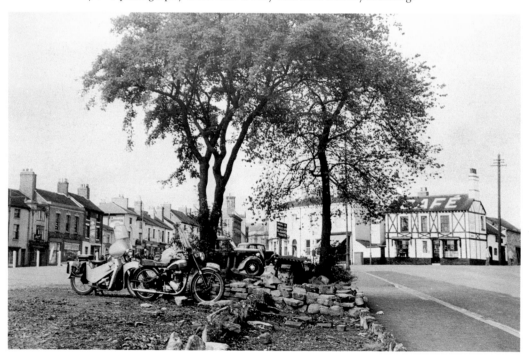

High Street – South End 1960s

The High Street south of Friars Street was called Penkhull Street until 1954 and extended much further than it does now. Shops and houses ran from today's Black Friar pub all the way down to Goose Street, opposite the Boat & Horses public house and into Brook Lane beyond. The 1960s view shows some of the shops still occupied whilst the modern version shows some of the heavy goods traffic that now passes over where those buildings used to stand.

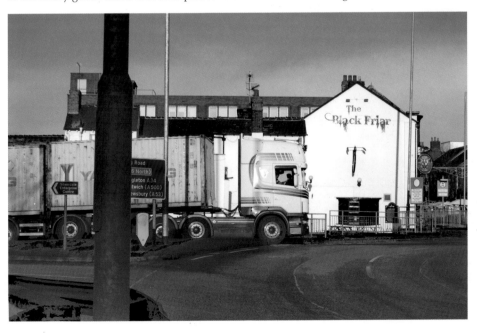

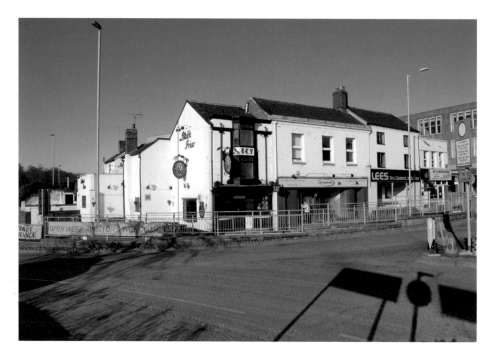

High Street – South End, 1964

This 1964 photograph shows the properties standing between those in the previous image and Paradise Street, some standing empty and ready for demolition. Both this and the modern version show a narrow Victorian building bearing the date 1897, formerly the Spread Eagle and now the Black Friar. The most noteworthy building in the row is the one formerly occupied by George Hollins' and currently standing empty. The lintels and pediment reveal it to be a relatively high status Georgian building.

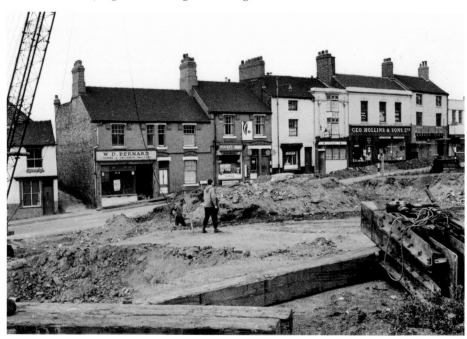

Paradise Street, *c.* 1935

Between today's Cash Converters shop and D-licious takeaway is Paradise Street, now home only to Jobcentre Plus and Blakey's Café bar. In 1912 though, there were twenty-two households here. The old view shows Paradise Street's sub-standard terraced properties from which, two years later, the population was evacuated *en masse* to Beattie Avenue, Cross Heath. As part of their re-location everyone's belongings had to be fumigated and a series of photographs at Newcastle Museum shows the various stages of this move.

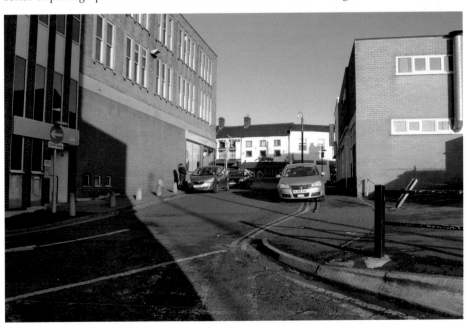

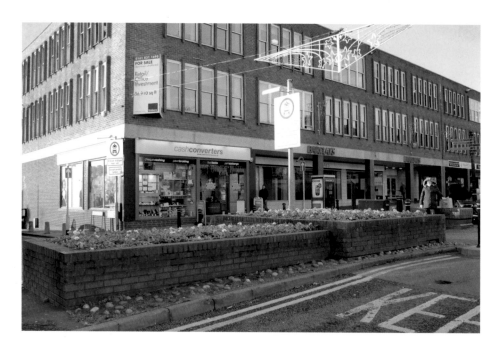

High Street, 1965

The hoarding advertising Regent Supreme petrol, renamed Texaco in 1967, and Havoline Oil stands on the corner of Paradise Street. The adjacent row of nineteenth-century shops including D. Ffoulkes florist, whose nursery and glasshouses were on Friarswood Road, Dunn's Pet Supplies, H. Smith confectioner, and the Kings Head public house, is mostly closed down and awaiting demolition. The recent photograph shows their replacement, a Lego-esque and characterless block housing shops on the street and the Jobcentre Plus offices above.

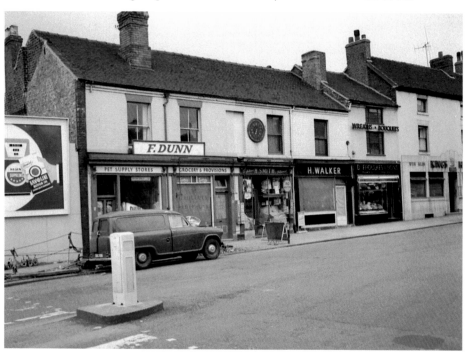

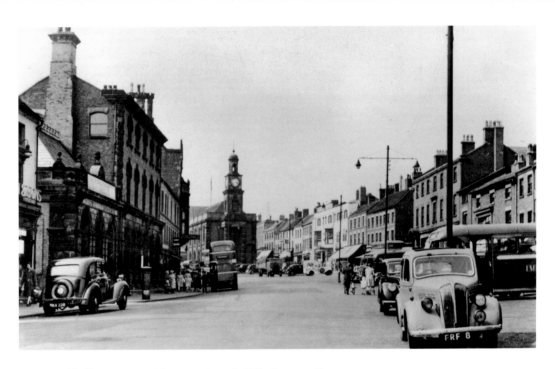

Penkhull Street, Looking North to Guildhall, *c.* 1948
This view towards the Guildhall was taken *c.* 1948 before this part of Newcastle's main street had its name changed from Penkhull Street to High Street. The street used to have to cope simultaneously with Newcastle's street market and busy traffic. On the left can be seen the old Liverpool and Manchester District Bank and beyond it, on the site now occupied by the Vue cinema, the Red Lion pub. Every single building on the left would later be demolished.

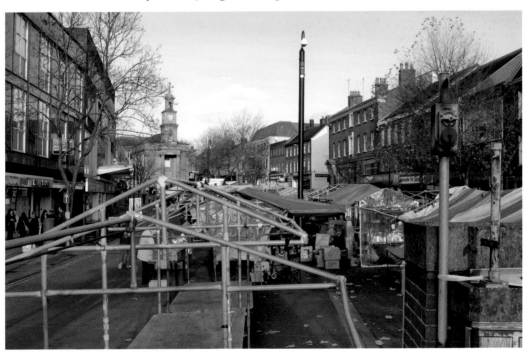

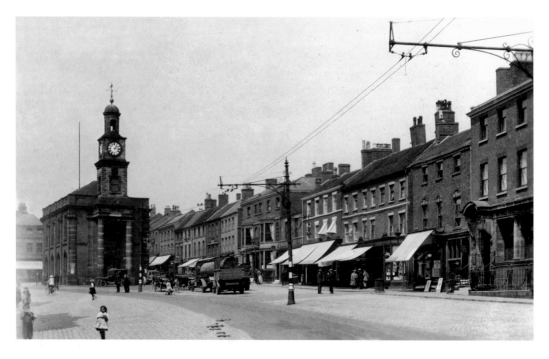

High Street Looking North to Guildhall, 1920s

This 1920s view of High Street is most interesting for something not there: Hassell Street. On the right is the National Provincial Bank and next door is a tearoom and the Home & Colonial Tea Stores. These were demolished *c.* 1930 allowing Hassell Street through to High Street. Along Penkhull Street and High Street still run the tram-cables, removed in 1928, except for one fitting still attached to the Guildhall. The modern photograph shows the many building changes that have occurred here.

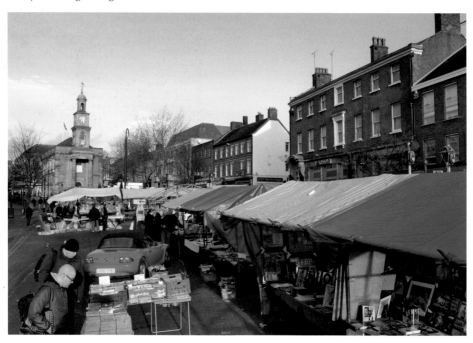

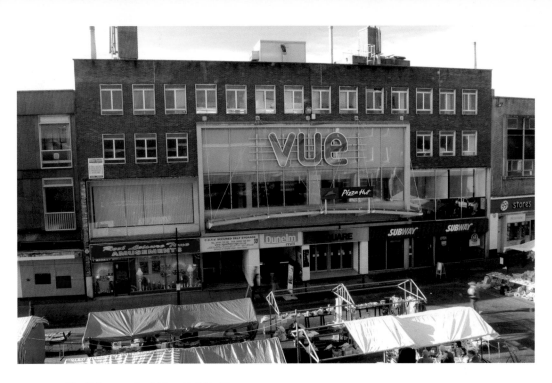

Penkhull Street, Red Lion Public House, *c.* 1940

This striking pair of photographs shows how a group of splendid buildings including the District Bank was replaced by the Market Arcade, now the Vue Cinema, and the 1957 Woolworth's building. In the earlier image next to the bank is Arthur Morgan's tobacconist and the Red Lion public house. Further to the right is the indoor market built in 1854, and beyond it the end of the Tudor Market Tavern pub, later a branch of F. W. Woolworth's '3*d* & 6*d*' stores.

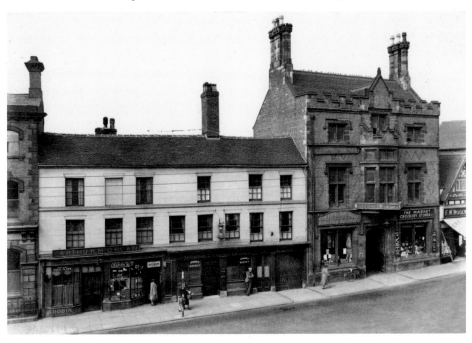

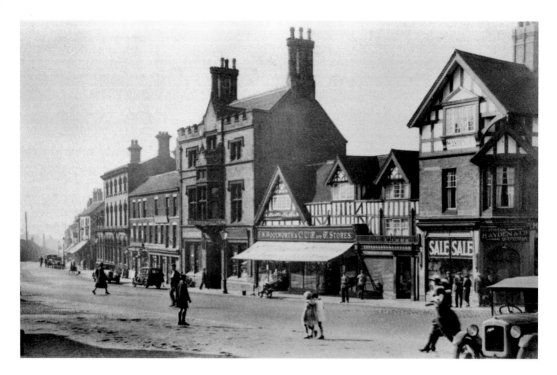

Penkhull Street 'Woolworth's Corner', 1930s
The difference between these views is absolute with the street name having changed from Penkhull Street to High Street on 1 January 1954 and every single building present in the early photograph having been lost. Most interesting of these is the black and white F. W. Woolworth's building which was removed in 1958. 'Removed' is appropriate here because Tudor buildings were pre-fabricated meaning that their frames can be dismantled piece-by-piece. This one is now in private hands awaiting to be rebuilt elsewhere.

Friars Street, Looking Towards Lower Street, 1937
Dramatically different views down Friars Street, where timber-framed shops and houses nestled cheek-by-jowl towards Lower Street. On the left was Spencer Collier's cycles and Alfred Collier's tobacconist and given their common doorway, these businesses were possibly connected. Lower down was John Henry Waldron's hairdresser's. The large wooden gates are the original Woolworth's goods entrance. Demolition would start in 1937 and be complete by 1953, allowing widening of the road and the building of the new Woolworth's store.

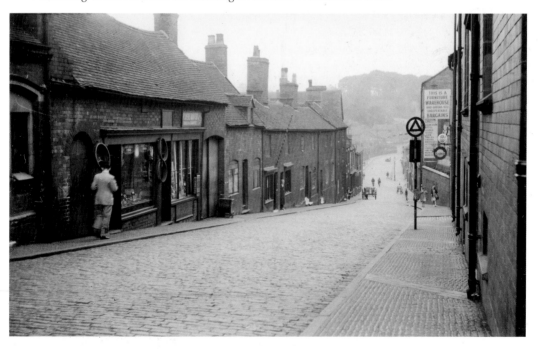

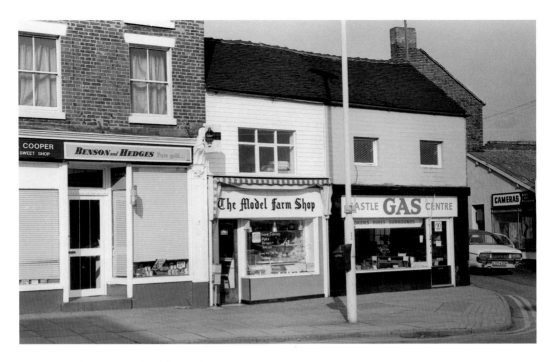

Hassell Street and Ball's Yard, 1970s

The 1970s sepia image shows where Balls Yard met Hassell Street. Originally, Balls Yard kinked sharply twice before narrowing to a very small passageway entering Ironmarket just above Miss Deakin's shop (page 40). Behind the Gas Centre can be seen perhaps the last surviving Ball's Yard building and to its right is Mott's camera shop. Of these buildings, only the former Cooper's sweet shop survives today, now occupied by H. Samuel, the jewellers. Ball's Yard has now become Castle Walk.

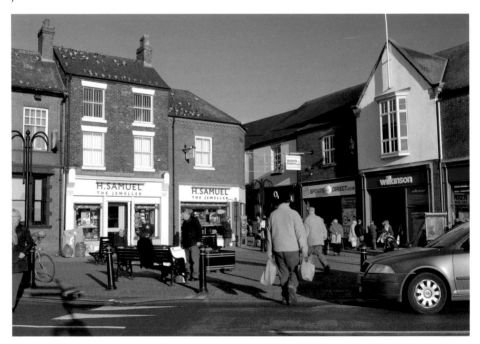

Ball's Yard, 1930s

This rather poor 1930s photograph of Ball's Yard may be the only one still surviving today. Although only used for parking and access to the rear of properties in Hassell Street for decades, Balls Yard used to house many poor families in two-up two-down terraces. In this photograph the buildings at the far end are in Ironmarket, the large building to the right being Jones Moss & Co.'s joinery workshop (see page 40). Compare this with today's mock-Georgian Castle Walk.

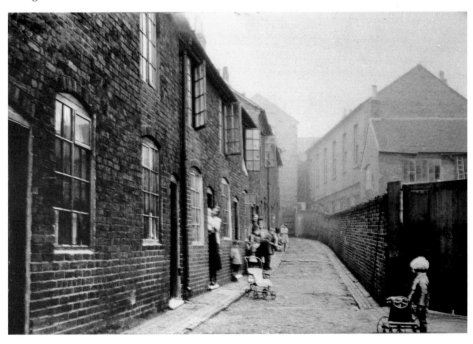

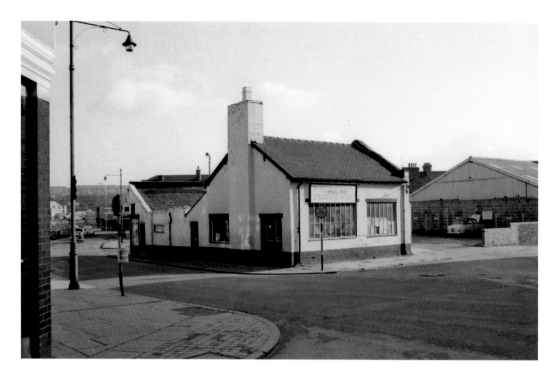

Hassell Street, Wainwright's Shoe Repairers, Early 1960s
This photograph shows Wainwright's 'shoe factory', a sign in the window stating that the business would soon be moving to new premises at No. 4 Hassell Street – a reduction being offered on all purchases to reduce stocks. At the left edge of both photographs is the door frame of the Bird in Hand pub currently Ikon. The recent photograph shows the new bus station covering the entire area surrounding where Wainwright's and the Labour Exchange beyond it used to stand.

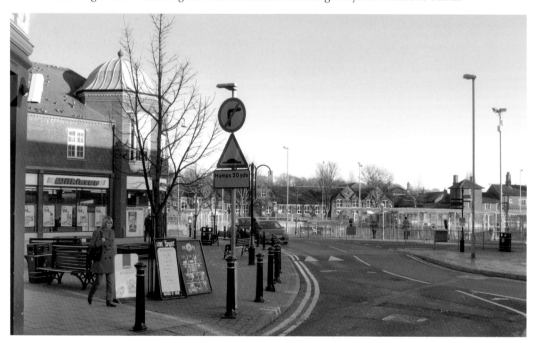

Hassell Street and End of Bow Street, 1970s

Although the sepia photograph was only taken in the late 1970s, much has now changed. On the right is what used to be the end of Bow Street, which curved around into Barracks Road. Here it merely serves as an access road adjacent to the 'new' bus station. The distant Ansell's pub is the Bird in Hand (see previous caption) which survives together with its neighbours, although the shops in the foreground have been replaced by Wilkinson's.

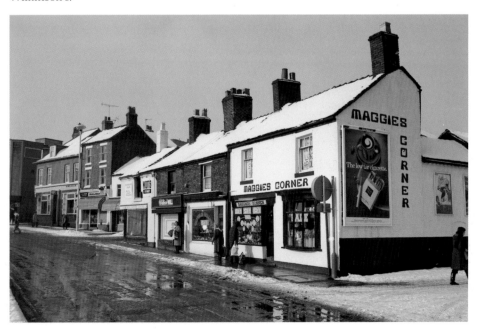

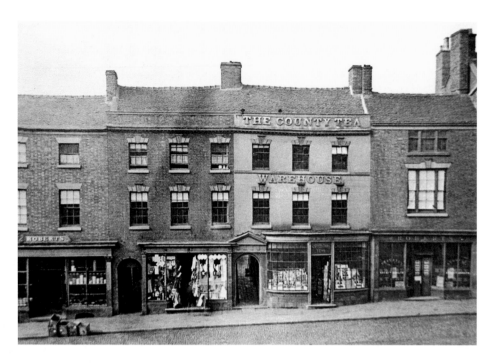

High Street, Dixon's County Tea Warehouse, 1870s

The shops in this 1870s Harrison photograph were built *c.* 1800 and one of them still survives today as Thomas Cook's travel agency. The shops can clearly be seen in an annotated diagram in Cottrill's Police Directory of Newcastle dated 1839. Although few would admire the changes in this scene at least the proportions of the McDonald's building match its predecessors and perhaps one day the original frontages could be recreated. The building to the right is common to both views.

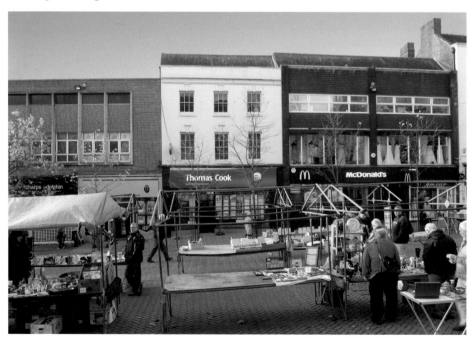

High Street, The Castle Hotel, 1968

In the 1968 photograph, the Castle Hotel approaches closure after 180 years. The hotel had been altered significantly since 1820 but planners would ensure that worse was to come. This once grand building now hosts two derelict shops and a completely unused second floor topped off by a hideous grey carbuncle that bears no resemblance to the original Georgian roofline. The Civic Society who worked hard to preserve the building's grandeur in the 1960s must feel disappointed today.

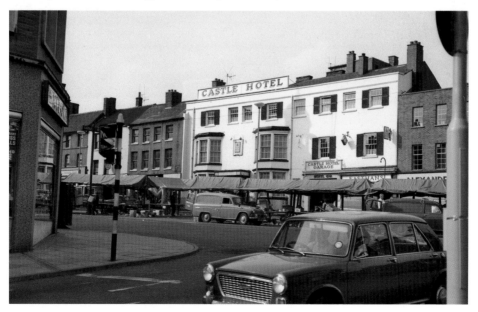

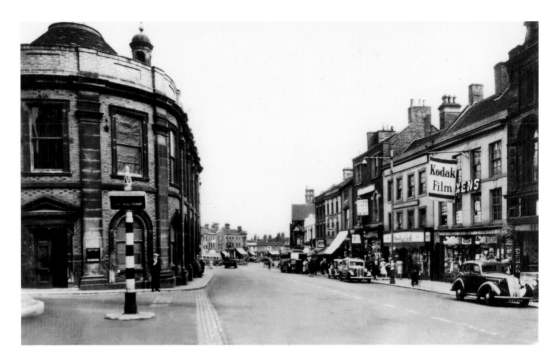

High Street and Guildhall, Late 1940s

Although these two photographs appear similar, on closer inspection the differences are enormous. The Guildhall has changed little but to its right the buildings are much altered. The buildings on both corners of Friars Street have gone, including the handsome Lamb Inn and most of the other buildings have either been replaced altogether or at best dramatically altered. To lengthen its saleable life the age of the sepia postcard was disguised by obliterating an air-raid shelter sign attached to Oxen's.

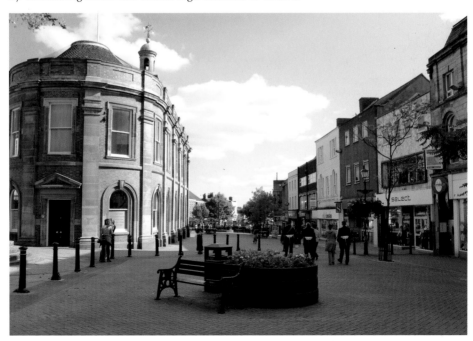

High Street Looking South Past Guildhall, 1865

This photograph was taken *c.* 1865 as evidenced by the licensee of the Rainbow Inn public house, Lewis Greaves. This is probably the only photograph to show the Tudor building next to the Castle Hotel and the Weights & Measures Office situated at the south end of the Guildhall (see Red Lion Square). Although the scene appears tranquil, that is only because moving pedestrians and horse-drawn vehicles registered only as ghostly images during the necessary long exposures of the time.

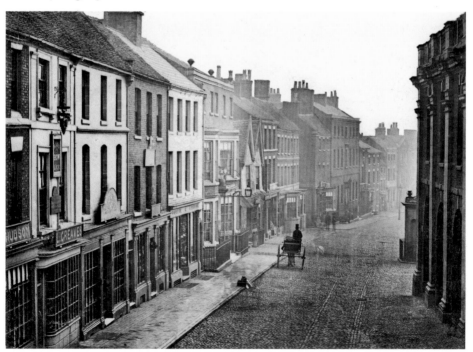

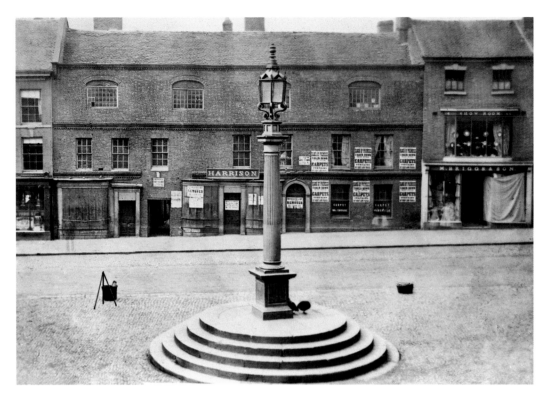

High Street, Newcastle Market Cross, *c.* 1873

This photograph shows Newcastle's market 'cross', behind which is the building just vacated by the photographer, Harrison's own business. It is alleged that Major General Thomas Harrison (no relation), Oliver Cromwell's second-in-command and signatory to King Charles I's death warrant in 1649, was born in one of these properties. Harrison was hanged, drawn and quartered at Charing Cross in 1660. On the modern photograph a plaque on HSBC's wall commemorates this although there are some doubts over its accuracy.

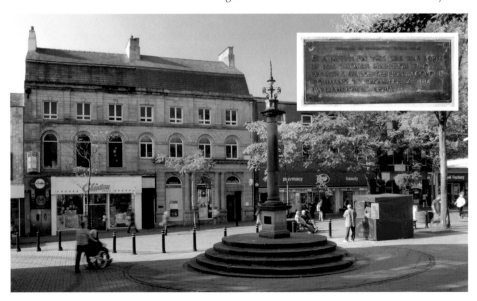

High Street, Old Roebuck Coaching House, 1930s

The 1930s image shows part of the Roebuck Coaching Inn, later altered to accommodate a number of shops and the police station. The building was demolished in 1936 to make way for the art deco Lancaster Building, which can be seen in the modern photograph. Outside the police station is a solitary police car, possibly Newcastle's entire fleet at the time. On the right is William Mellard's ironmongery which traded from here for more than a century.

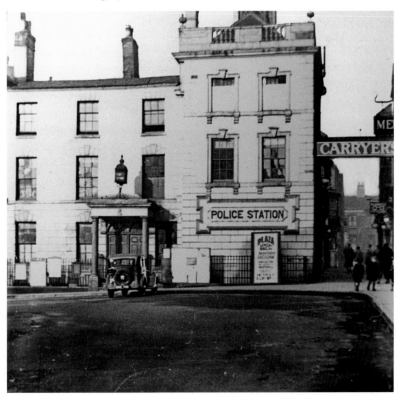

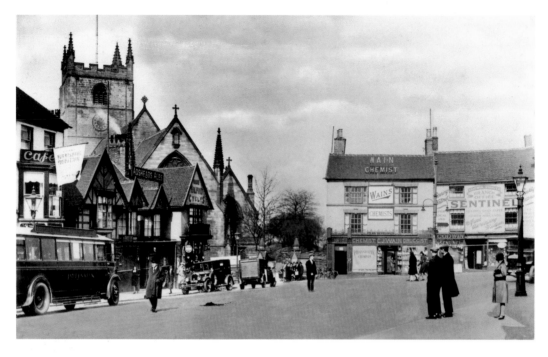

Red Lion Square and St Giles Church, *c.* 1930
The early view of Red Lion Square taken about 1930 shows another of Newcastle's timber-framed buildings swept away in the name of progress. The building was shared by the Three Tuns pub and Halford's Cycles. It may have been Halford's who demolished the building in 1958 because they were one of the first occupants of the plain, box-like structure that stands there today. The modern photograph shows the trees that can be found throughout Newcastle and the 1992 war memorial.

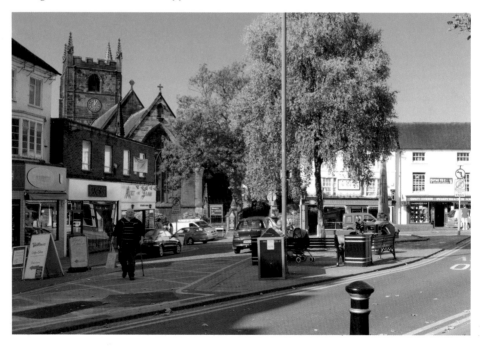

Red Lion Square, The Hinds Vaults and Globe Hotel, Late 1960s
These two photographs show very clearly the transition from interesting old Newcastle buildings to more utilitarian modern ones. The 1968/69 York Place Shopping Centre is not utterly unattractive but it replaced the sixteenth-century timber-framed 'Hinds Vaults' pub, a row of Georgian shops and the lofty former Globe hotel with its terracotta half globes. Bookland last occupied the 1898 Globe whose eighteenth-century predecessor was also recorded by Newcastle photographers. Today trees obscure the view for most of the year.

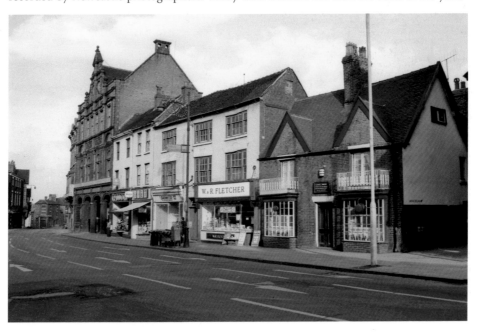

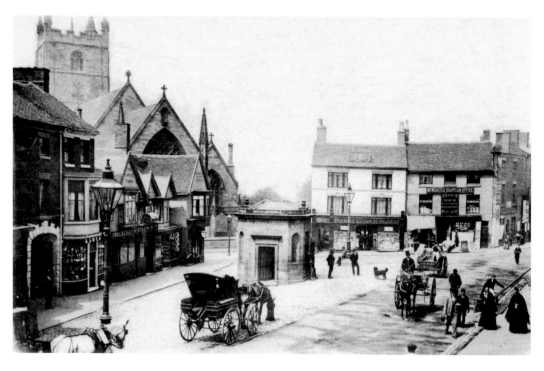

Red Lion Square with Weights & Measures Office, 1890s

This *c.* 1900 view of Red Lion Square is fascinating in that it is a glimpse into a time when there were no motor vehicles, no electricity, and the pace of life was much slower than today. Horses were prevented from moving by the simple expedient of providing them with a nosebag of oats. The Weights & Measures Office stands outside the Three Tuns having been moved from the south end of the Guildhall in 1876 (see page 23).

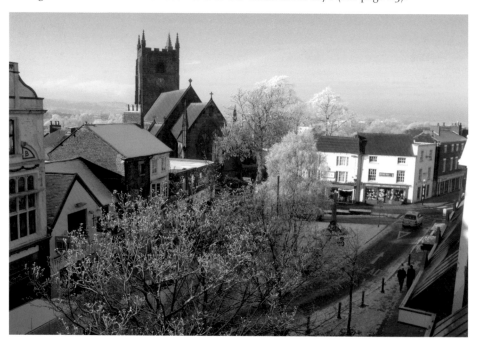

Red Lion Square, End of Merrial Street, 1870s

Edwin Harrison appears to have photographed every aspect of Red Lion Square in the 1870s. Although the scene looks very different today, two of the buildings in Harrison's shot can still be seen although John McKee's draper's has been completely rebuilt. Merrial Street was very narrow then and was only widened in 1967 when York Place shopping Centre was being built. Ghostly women in the long dresses of the day wait to cross Merrial Street outside the Happyland Vaults.

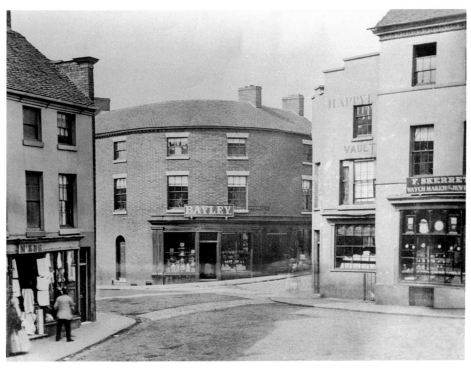

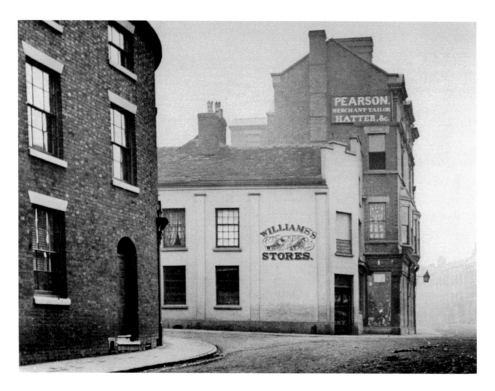

Red Lion Square, End of Merrial Street, 1880s

The early photograph here also shows the junction of Merrial Street with Red Lion Square but looking in the opposite direction. The businesses have changed with Williams's Wine & Spirit Stores now on the corner of Merrial Street and the next-door property having been rebuilt to house both Pearson's tailor and hatter and Skerratt's jewellers. This building was so tall that it shows up on many views of Newcastle (see Bridge Street). These buildings survived until 1967.

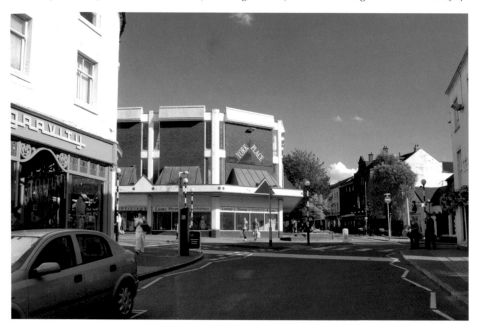

Red Lion Square, Georgian St Giles Church, 1870s

The Victorians and in particular the architect Sir George Gilbert Scott were responsible for demolishing huge numbers of ancient English churches and replacing them with the Gothic versions we see today. The St Giles church we see today was built under Scott's direction between 1873 and 1876, replacing the Georgian church, shown in the early photograph. The earlier church had opened for worship in 1725. The tower, although re-faced, is largely original and has stood attached to a total of three churches during its 700 year history. The church which preceded the Georgian one allegedly had its thatched roof destroyed by a mob consisting largely of its own parishioners during their efforts to burn down the nearby Unitarian Meeting House in 1715. Egerton Harding (see page 42) was implicated in this attack.

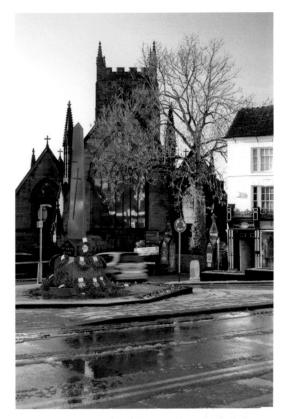

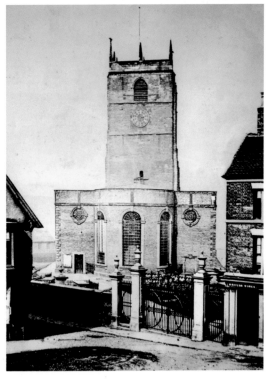

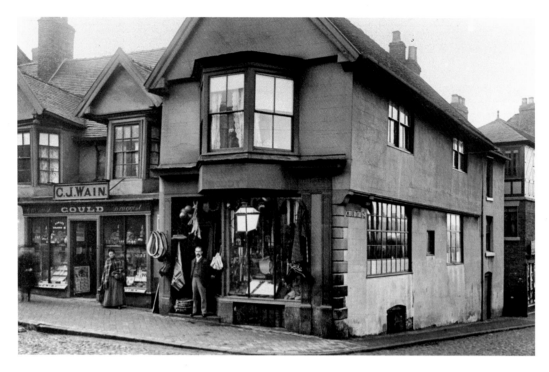

Red Lion Square, Corner of Church Street, 1890s

On the corner of Church Street and Red Lion Square stood a Tudor building containing the Three Tuns public house, Clement Wain's original chemist's and Moody's saddlery. Wain (see inset) moved into the building, which still bears his name today, in about 1895 and Moody's became Matthews' saddlery and later Halford's bicycle shop. The timber-framed building was demolished in 1958 and replaced by the building now housing the Art of Siam Thai restaurant, although Halford's and Frame's travel agents occupied it previously.

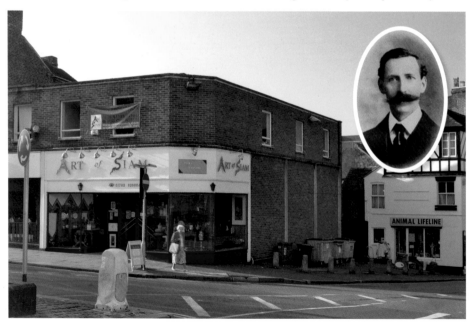

Merrial Street, Looking Towards the Civic Offices, 1966

This 1966 photograph shows Merrial Street from the Central Hotel to where the new Civic Offices are under construction. The Georgian buildings housing Sylvester's Music Shop and Babyland are shortly to be demolished; a sign in Sylvester's window announces that they will soon be moving to the Midway. York Place Shopping Centre seems unlikely to last the nearly 200 years of its predecessors and some years ago a large section of concrete pediment crashed to the pavement in Lad Lane.

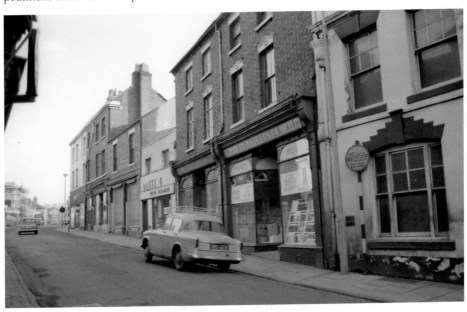

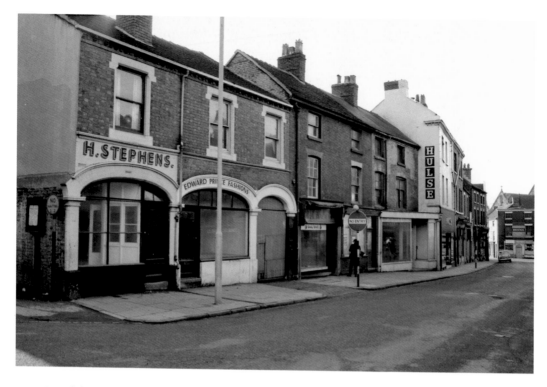

Merrial Street, Looking Towards Red Lion Square, 1966

Taken within a few minutes of the previous photograph – note the Hillman car outside Sylvester's on both – this view shows the same row of shops looking towards St Giles church. The buildings look perfectly sound and appear to have flats above them. These days very few people live within the circle of dual carriageways that surrounds the town centre. Most of today's town-centre residents live above pubs or in a few flats above the shops in Bridge Street.

Red Lion Square, From Behind the Weights & Measures Office, *c.* 1920
This very unusual 1920s photograph is taken from behind the Weights & Measures Office in Red Lion Square. The sloping handrail within the railings reveals the presence of underground gentlemen's 'conveniences' here; perhaps they still survive beneath the road? Every building in this photograph has since been demolished, with the exception of the Guildhall (far right) and the Burton's building, whose roof and chimneys are just visible. The recent photograph shows the York Place Shopping Centre, which opened in 1968.

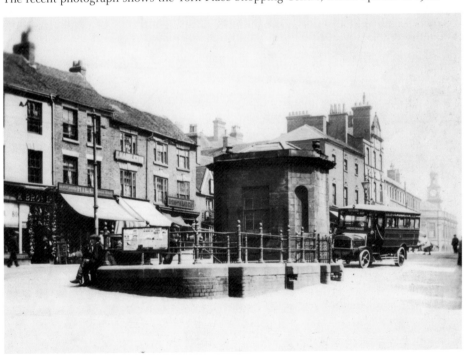

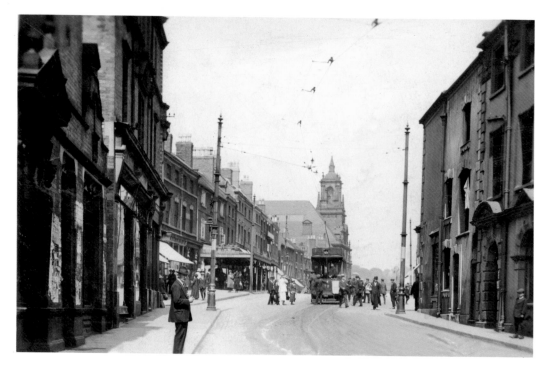

Ironmarket, Looking North-East, *c.* 1920

This is the junction of Newcastle's second major street, Ironmarket, with High Street. The large building on the right, originally the Roebuck Coaching Inn, obscures the properties on that side but in the modern view it can be seen that the street is now much wider. Also astonishing is that the Ironmarket, which has largely been pedestrianised, is now filled with trees rather than trams and other traffic. The Municipal Hall appears, and disappears, here for the first time.

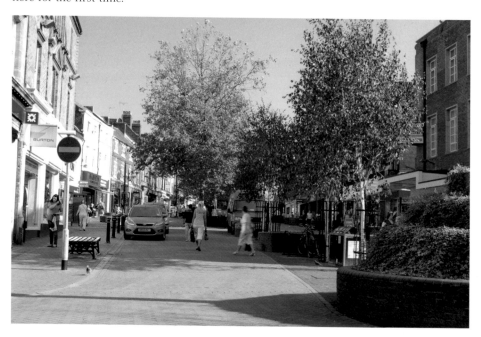

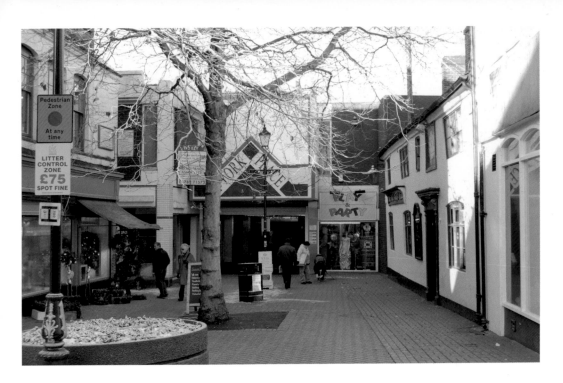

Lad Lane, *c.* 1968

Lad Lane runs, via a right angle, from Red Lion Square to Ironmarket, maintaining the block of buildings containing Burton's as an island. The buildings to either side remain unchanged in these two views but facing the Ironmarket the differences are significant. The old buildings were swept away in 1969 to form an entrance to York Place Shopping Centre, providing access from Lad Lane to Merrial Street. The rather gloomy interior always seems more of a short-cut than a destination.

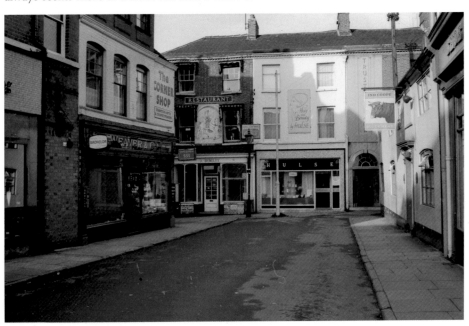

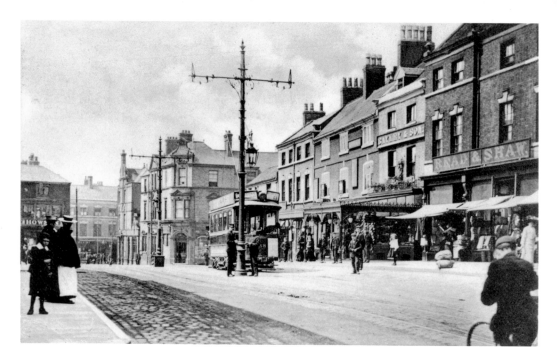

Ironmarket, Looking South-West, *c.* 1914

In these views of Ironmarket, taken nearly a century apart, only two buildings have changed, the old post office, on the right hand corner with High Street, has been replaced by a bank and the old Roebuck no longer narrows Ironmarket at the High Street end. It is now difficult to imagine the pre-pedestrianised Ironmarket where outside Henry White's gent's outfitters was a major tram, and later bus, stop with passengers escaping bad weather under the cast-iron and glass arcade.

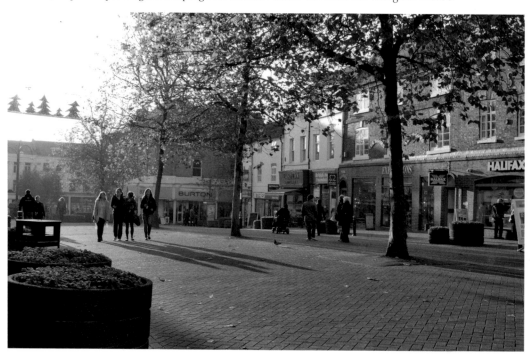

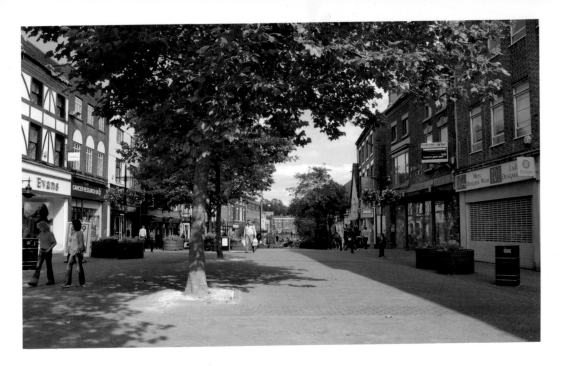

Ironmarket, the Municipal Hall, *c.* 1905

This view of Ironmarket shows how the Municipal Hall towered above the town, dwarfing everything around it. Many other buildings in this area have survived unlike the 'Muni' itself, which only stood for seventy-six years until 1966. Incredible though it seems, in four years Lancaster Buildings will have outlasted the Municipal Hall and yet the demolition of the Municipal Hall nearly fifty years ago can still provoke outrage in any gathering of older Newcastilians.

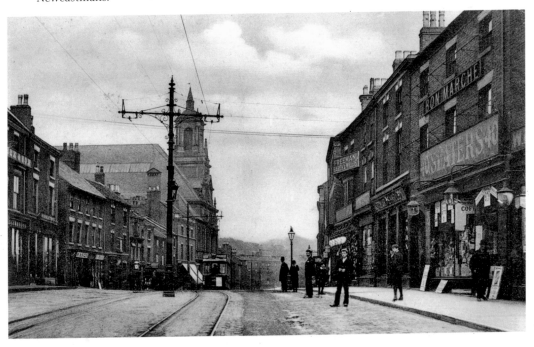

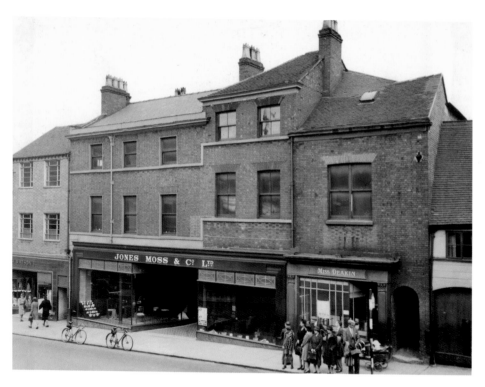

Ironmarket, Watsons, Jones Moss and Miss Deakin's Shops, *c.* 1940
The two shops in the centre were demolished in the 1960s and replaced by the Co-op's multi-storey Castle House store. Next to Miss Deakin's is the entry to Ball's Yard. To its right is the 'Star' public house, now the '80s Bar', which began life in the medieval period. On the wall of Deakin's a tram-wire bracket was left *in situ* when the trams ceased running. Castle House was replaced by the mock-Georgian buildings flanking the entrance to Castle Walk.

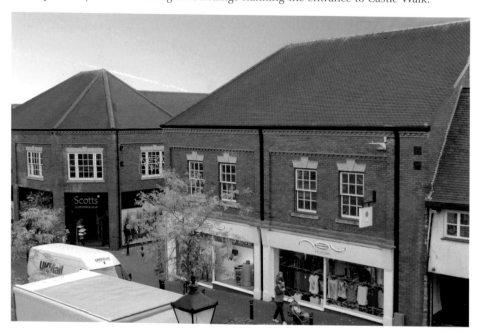

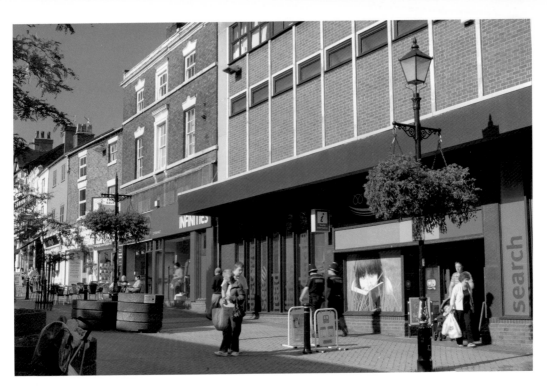

Ironmarket, Steps House and Arlington House Garden, pre-1888

The grand gentleman's house pictured in this early view seems very alien to today's Newcastle and yet here it is in the modern photograph. Next to 'Steps House', as it was known, is the garden of Arlington House, of which one or two photographs also survive. Arlington House was demolished to make way for the Municipal Hall which in turn gave way to a building intended to be used as a supermarket, but eventually occupied by the library instead.

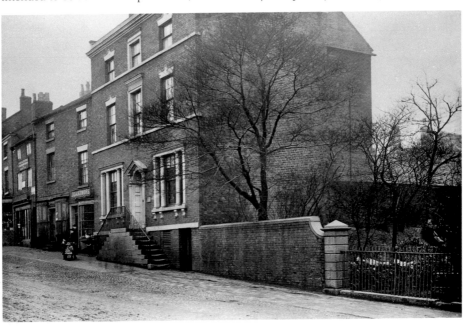

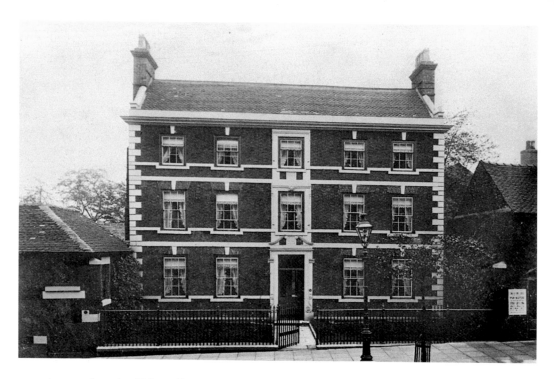

Ironmarket, the Old St Giles Rectory I, *c.* 1900

Perhaps the biggest surprise to local history newcomers is the fact that this magnificent house, built in 1698 for the Reverend Egerton Harding, Rector of St Giles, still survives, although today much altered. When a new rectory was built in Seabridge Road in 1926 this building became a medical centre until 1936 when it was converted to shop use. Today, The Rectory Chambers are occupied by a newsagent, a steak-bar and one empty shop, above which are office premises.

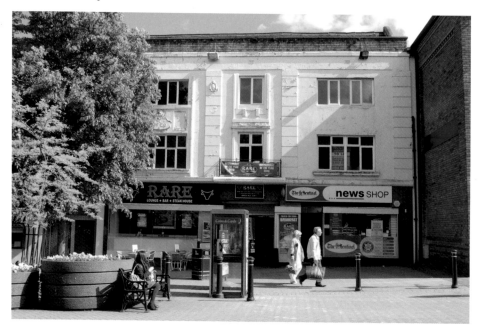

Ironmarket, the Old Rectory II, *c.* 1900

Another view of the old Rectory showing the wing that extended into the large garden at the rear. Next to the house was a range of stables and coach buildings and, next to that, a field on which the clergyman's horses would have been grazed. The outbuildings were replaced in 1914 by Newcastle's new main post office and later by the extension forming The Rectory Chambers. The grazing land became the Queen's Gardens in 1897.

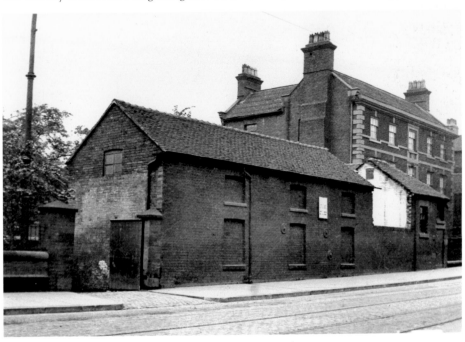

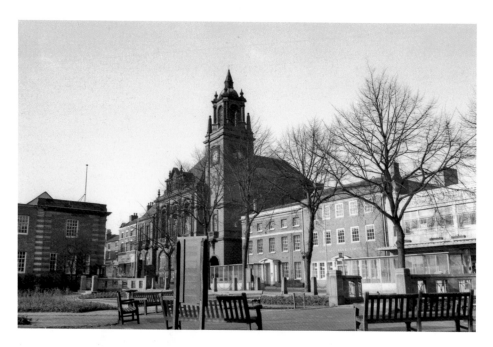

Ironmarket, the Queens Gardens and Municipal Hall, Early 1960s
The early 1960s photograph taken from the Queens Gardens shows the imposing Municipal Hall which, despite its apparent popularity with the townspeople, was completely inadequate for housing the offices of the council. These offices were scattered around the town in numerous buildings. The Borough Treasurer's office for example was housed in the large eighteenth-century building situated behind the person taking this photograph (see p. 48). The new photograph shows the statue of Queen Victoria in its third and current location.

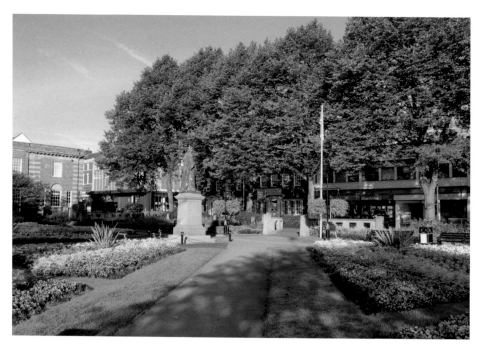

Ironmarket, Co-operative Society Emporium, Late 1920s

This late 1920s photograph shows yet another grand private house on the edge of the town destined to be sacrificed in favour of commerce. The large ornate property in the centre was demolished in 1930 and replaced by the art deco Co-operative Society Emporium that still stands today, although no longer occupied by the Co-op. Its neighbour would later befall the same fate and be replaced by the post-1967 box-like building now occupied by the Leeds United Building Society.

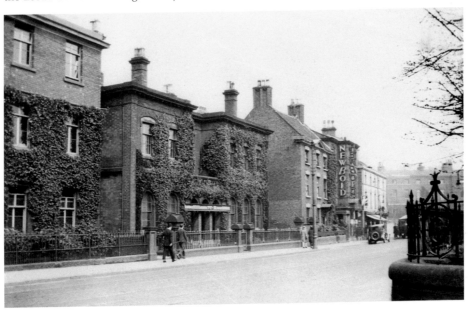

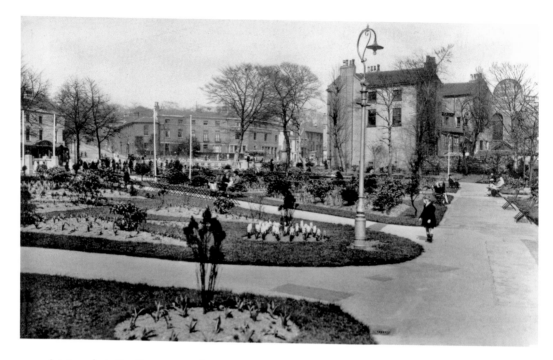

Ironmarket, the Queens Gardens and Borough Treasurer's Office, c. 1930

This photograph of the Queens Gardens appears rather boring without close scrutiny. Beyond the gardens is the rear of the Borough Treasurer's offices and the other Georgian buildings around Nelson Place including the cinema, originally a theatre. Also visible are the original swimming baths, the fire station and Queen Victoria's statue in its original location. This scene looks attractive today with its flowers and mature trees but would Queen Victoria be amused at having been uprooted twice in a century.

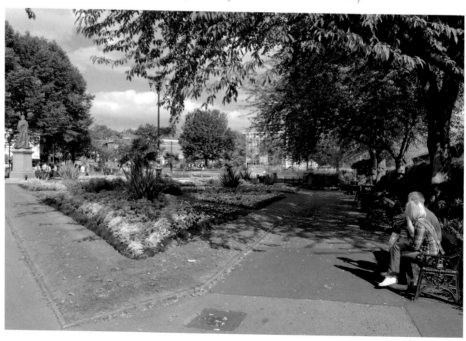

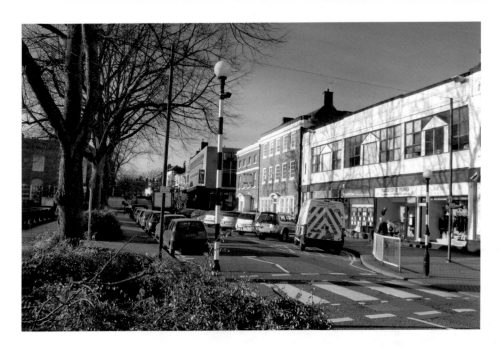

Ironmarket, the Municipal Hall, 1890s

This pre-1900 view of Ironmarket shows the building later to become the Co-op Emporium. What it also shows is that even at the beginning of the twentieth century buildings were sometimes being altered with attempts being made to preserve their character. The building above the Co-op site had changed from being two storeys as here to three storeys in the previous (later) pictures. The saplings on the left in the early view are the mature trees still there today.

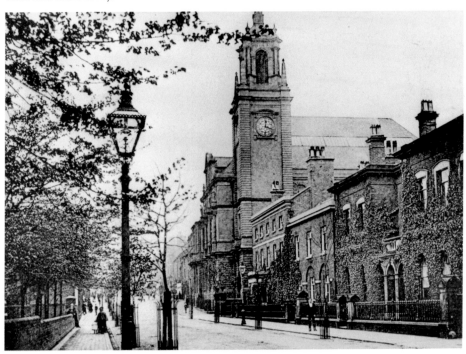

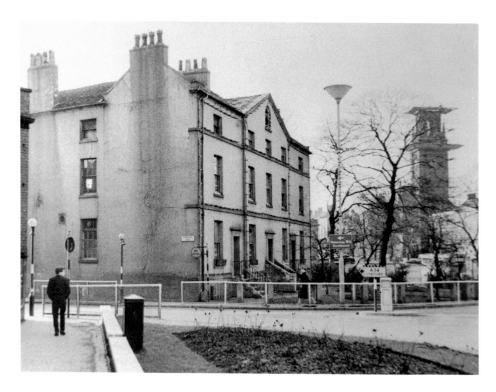

Nelson Place, the Borough Treasurer's Office, 1966

The bust of Horatio Nelson that probably gave Nelson Place its name can be seen in the central pediment of this grand Georgian house. When the building was demolished the bust was entrusted to the Borough Museum and restored (see inset). To the right can be seen the beginning of the end for the Municipal Hall. There was such a call for at least the tower to be saved that work was temporarily halted, although eventually the entire building was demolished.

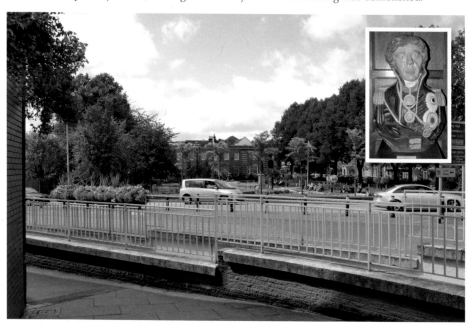

Nelson Place from King Street, 1963

This 1963 view shows Nelson Place from King Street. The paling fence to the left shows where the 1787 Royal Theatre, converted into the Cinema Theatre in 1910, has just been demolished. Later that year Queen Victoria's statue would begin its forty-year exile in Station Walks, allowing the roundabout to be enlarged. Later the Borough Treasurer's building and the 'Muni' would also be demolished and Marsh Street and Barracks Road widened and converted into dual carriageways.

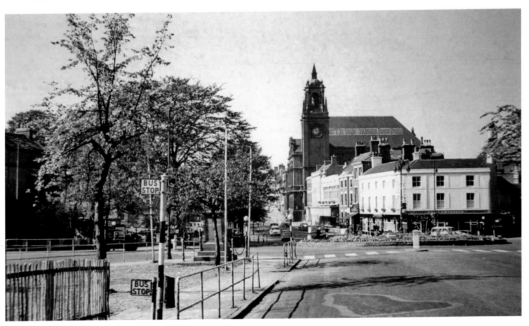

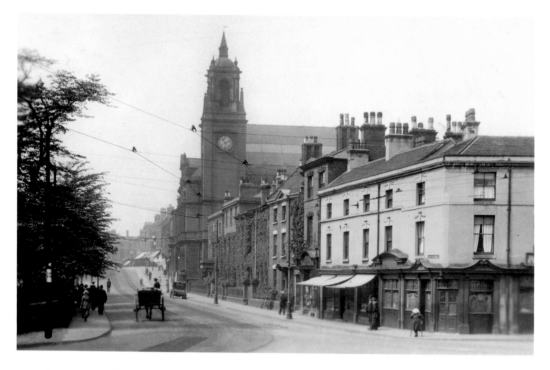

Ironmarket, the Compasses, 1920s

The superbly sharp 1920s photograph shows the view from Nelson Place up Ironmarket. Vehicular travel at this time would have been by horse-drawn vehicle, electric tram or, for the fortunate few, private motor car. Soon trams would give way to buses, and cars would become more common than horses. The large Georgian building on the corner is the Compasses pub built *c*. 1790. Today it is occupied by 'Lace', a so-called 'gentleman's club'. Note the absence of chimneys in the modern view.

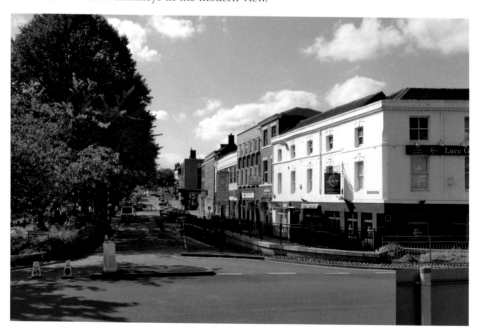

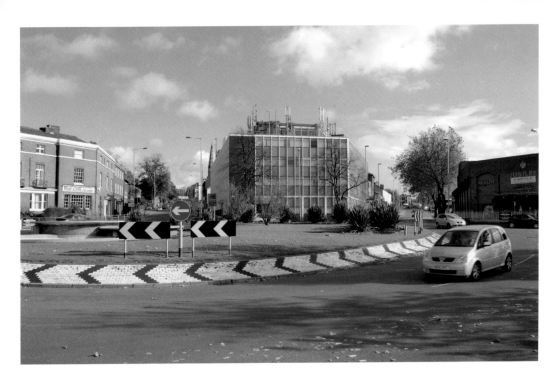

Nelson Place, the Plaza Cinema, c. 1930

The old photograph dates from when silent films were giving way to 'talkies' in Newcastle. The Cinema Theatre, later the Plaza and then the Roxy, had begun showing films in 1910 and showed its last film in 1957. The plaque of Shakespeare in the centre of the frontage now adorns the New Victoria Theatre in Basford. The Nelson Place development replaced a foetid marsh where for centuries Newcastilians had habitually dumped human and animal excrement, carcasses and other rubbish.

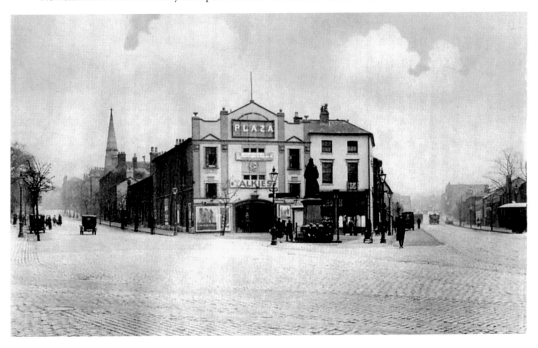

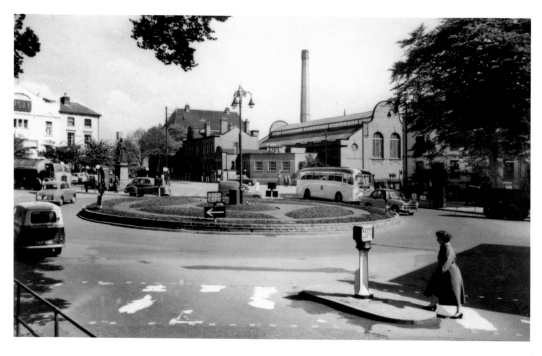

Nelson Place, the Roxy Cinema and Swimming Baths, *c.* 1960
This photograph shows Nelson Place from the end of Marsh Street. From left to right, around a much smaller roundabout than today, can be seen the Roxy Cinema, Brunswick Methodist Chapel, the original swimming baths with their tall boiler chimney and just visible behind the trees the Borough Treasurer's offices. The view is almost unrecognisable today and the only thing that survives from the early photograph is the lower part of the swimming baths end wall.

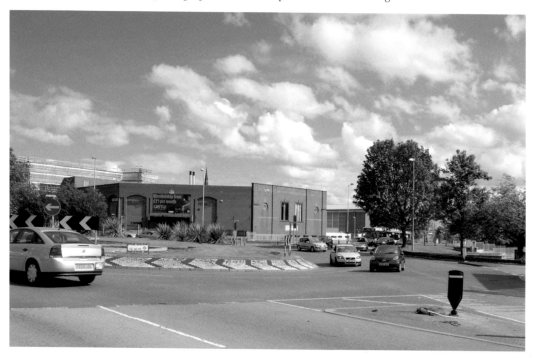

Croft Street, Shoreditch and Marsh Street, 1934

This photograph was taken in 1933/34 as evidenced by the Savoy cinema poster that also appears on page 61. Here the photographer stands on Croft Street looking towards Shoreditch, a street of mean terraced properties beyond the further schoolboy. Today no trace of Shoreditch exists. Beyond Shoreditch is the rear of the Ebenezer schoolrooms in Marsh Street, now part of Merrial Street, and shrouded in mist, the rear of the Muni. Only the ivy-covered Ebenezer schoolrooms still survive today.

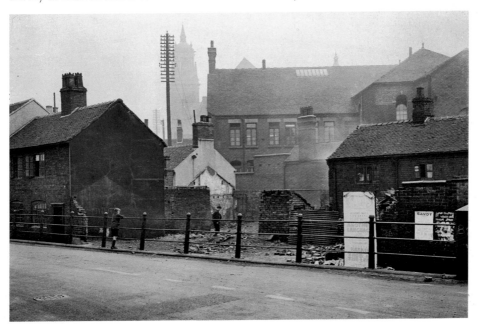

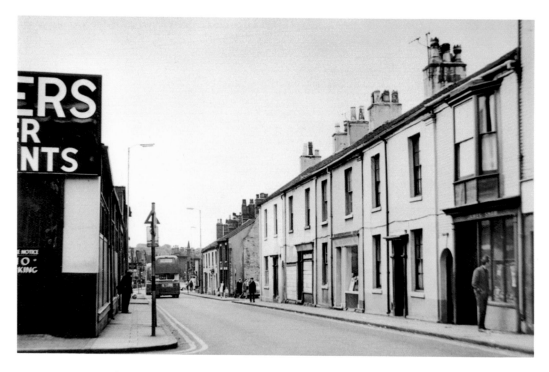

Barracks Road, Looking South, 1967

Before 1 January 1954 this road up to its junction with Hassell Street was known as Bagnall Street. Until around 1900 Barracks Road began at Hassell Street and ended at the barracks, just visible in the distance. The modern photograph shows how all of the houses and shops on the right were swept away to allow a massive widening of the road, eliminating Bow Street on the right and exposing St Giles and St George's School, currently standing boarded up.

Bagnall Street, Elephant & Castle Beer House, c. 1910
This early view of Bagnall Street looking towards Nelson Place contains possibly the only photograph in existence of the Elephant & Castle beer house, run at the time by Joseph Buck. Beyond the pub, J. Marsh & Sons Funeral Directors, still in business today, advertise themselves as 'practical coffin' makers; it has to be wondered what constitutes an *impractical* coffin? In the distance is the roof of the swimming baths and Queen Victoria's statue. How different this scene is today.

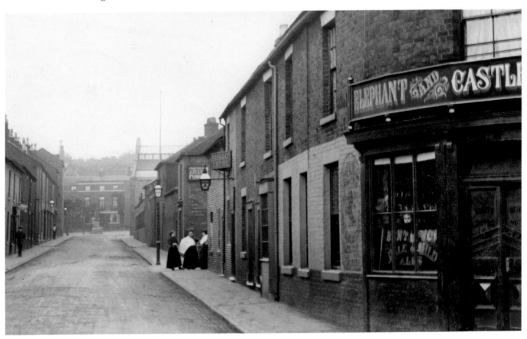

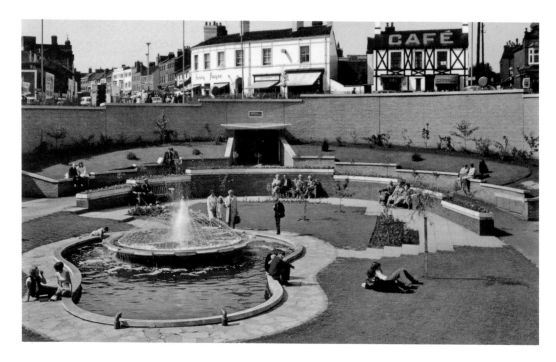

Grosvenor Gardens Roundabout, Late 1960s

The Grosvenor, or 'sunken gardens' roundabout was created in the mid-1960s and this photograph shows the gardens shortly afterwards. The fountains were soon removed and converted to flower beds. The white building beyond the gardens used to be the Antelope Inn and the gap between that and the former Magnet café has now been filled in. To the right of the café can be glimpsed the building at the end of the now demolished terraced properties in Barracks Road.

Lower Street, Friars Street Roundabout, 1966

Lower Street is no longer really a street as most of its buildings have gone, except part of the Old Queen's Head public house, now a business fitting windscreens. The 1960s photograph looks northwards along the new dual carriageway towards Holborn Paper Mill. On the right the Methodist Chapel has just been demolished and the Midway multi-storey car park is set to replace it. The roundabout trees have survived but Blackfriars Bakery, the Smithfield public house and its neighbours have not.

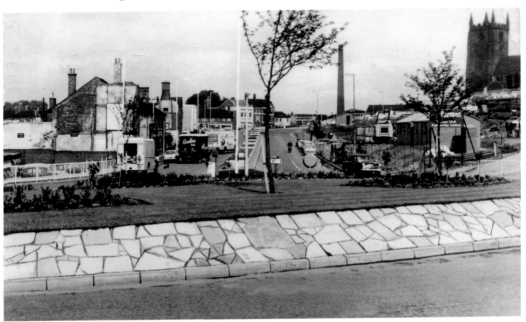

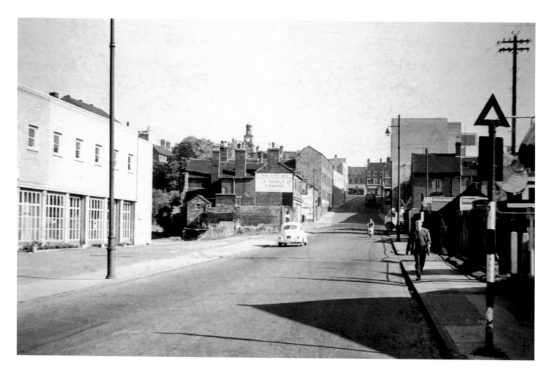

Blackfriars, Blackfriars Bakery and Friars Street, Early 1960s
This old photograph shows the Ship Inn probably unseen on any other photograph, advertising Ansell's beer. It stands directly in the path of the A34 ring road and Double Diamond worked no wonders here as the Ship was swept away permitting the opening of the ring-road in August 1965. On the left side of the photograph is Blackfriar's Bakery, built on the site of Baker Street, another poor, terraced street demolished in the large-scale clearances of the 1930s.

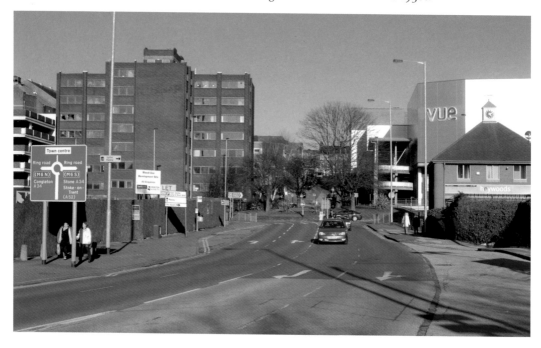

Junction of Lower Street, Holborn and Pool Dam, 1934

It is difficult to reconcile these two photographs; in the early view it is only the old Orme School and terraced houses in the distance that show that the photograph was taken from the bottom of Church Street. The road running across the photograph was Lower Street, now replaced by the A34 ring road. All of the buildings in the middle ground have gone including the large Fox and Goose Inn visible on the corner of Pool Dam and Lower Street.

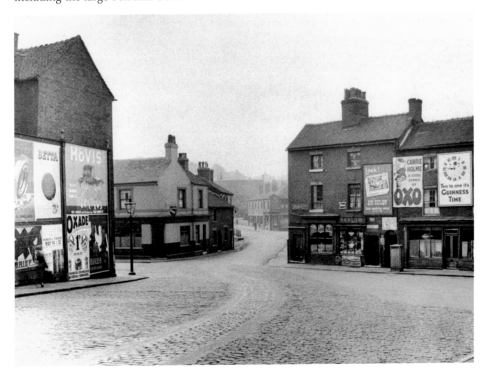

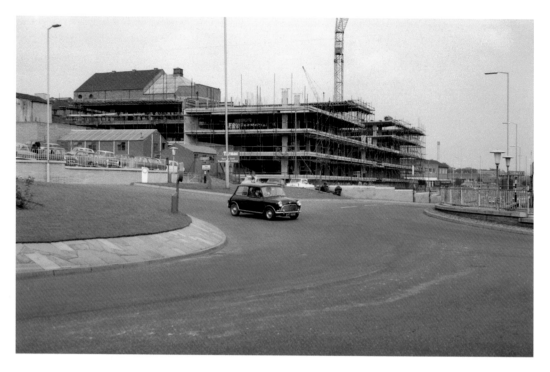

Lower Street, Midway Multi-Storey Car Park, 1966

Taken in 1966, this photograph shows the same roundabout as in the previous modern photograph. The Midway multi-storey car park is under construction but the background is perhaps more interesting. Burgess's agricultural merchants are at the bottom of Friar Street, with the former Pepper's Garage beyond it. To the left can be seen the rear of Sutherland House, formerly the Roebuck Coaching Inn with stabling for seventy horses, and the Savoy Cinema. This is a dramatically different scene today.

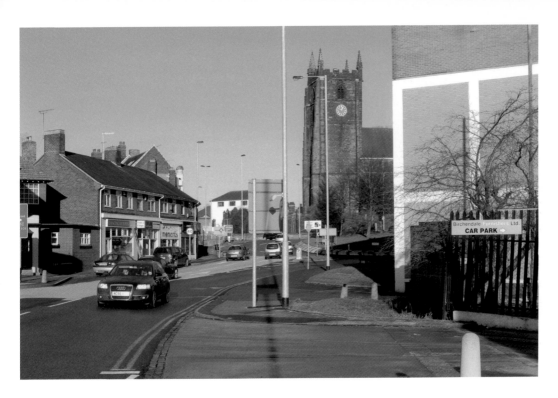

Pool Dam Looking Towards Church Street, 1934

The films *Another Language* and *This is the Life* advertised on the Savoy Cinema poster opposite the John O'Gaunt's Inn date this photograph to around 1934. The photograph is taken looking towards the bottom of Church Street and is an opposite view from the one on page 59. Most interesting is the fact that buildings can be seen between the road and St Giles' churchyard, where today there is only the A34 in front of the high churchyard wall.

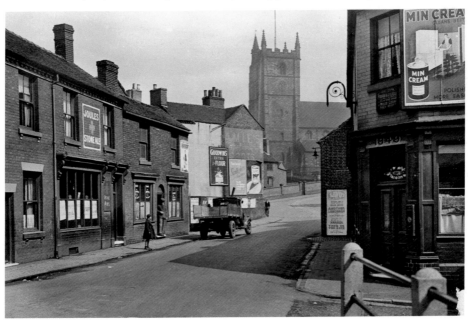

Pool Dam, Garner's Seed Merchants, 1979

This view shows Pool Dam from the dam itself towards Lower Street. Until the 1850s a pool still existed opposite the mill occupied by Garner's Farm & Garden Supplies. Having been there at least since 1841 the mill was demolished relatively recently, although the car business that required its demolition moved out relatively soon afterwards and its replacement is now also closing down. The mill's neighbours including S. A. Whitbread's Pool Dam Garage were demolished much earlier.

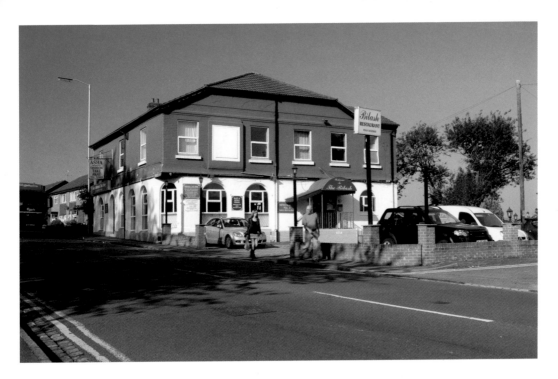

Higherland, The Lord Nelson Hotel, Mid-1970s

A Lord Nelson Hotel was in existence on Higherland by 1834, although not this building, together with at least four other pubs: the Sneyd Arms, the Waggon & Horses, the Unicorn and the Dyers Arms. Today only The Waggon and The Sneyd survive. As the recent photograph shows the Lord Nelson building has now been significantly altered and serves not as a pub but as the Bilash restaurant and Asha Tandoori Takeaway.

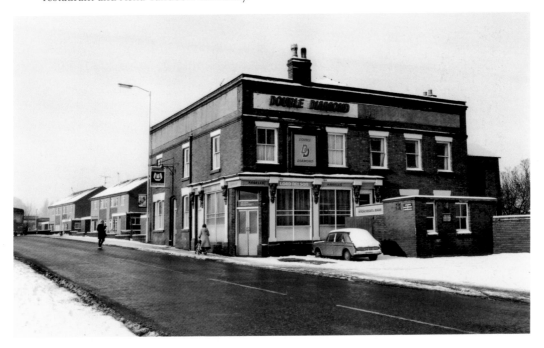

Higherland, H. & E. Shaw's Newsagent, 1960s

In this 1960s photograph looking towards Keele, H. & E. Shaw's newsagent stands alone on the left side of the Higherland. It was formerly in a row containing Eardley's shop and terraced housing. Shaw's comics and toys were an irresistible temptation when pocket-money needed spending. Opposite it stood other shops and houses leading up to the Sneyd Arms public house and beyond. Behind the apparently unwilling photographic subject can be seen Burke's filling station and beyond that their car showroom.

Higherland, Georgian Shops Between Pool Street and Union Street, 1960s

The 1960s photograph of the Higherland by Bill Colville shows the row of Georgian houses and shops that stood between Pool Street and Union Street and included Clarke's grocer, Simpson's post office, and Ashley's grocer. Behind these buildings was a grid of streets containing eighty to 100 terraces with their own pubs. In the distance is the side of the Lord Nelson pub. The modern photograph shows the semi-detached houses and their gardens that replace these shops today.

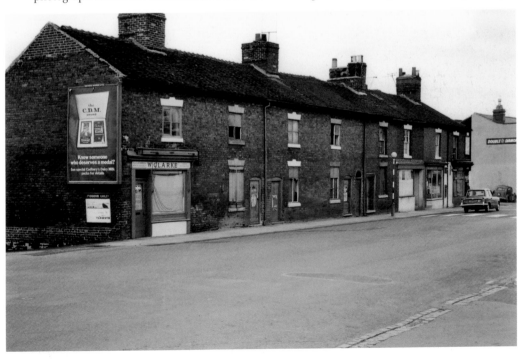

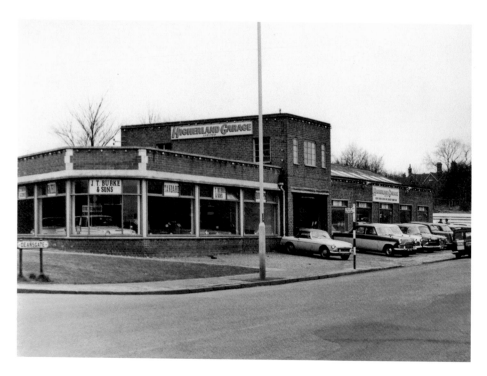

Deansgate, J. T. Burke's Car Showroom, c. 1964

This pair of photographs shows how an existing building can be adapted and given a new lease of life. J. T Burke's Higherland Garage showroom and workshops, built in 1953, are shown here with their stock of Consuls, Zephyrs and super-modern Cortina Mk I's. In the recent photograph the building has been clad in modern materials and a new first floor added above the old showroom. The Deansgate sign has disappeared and the name is probably no longer in common usage.

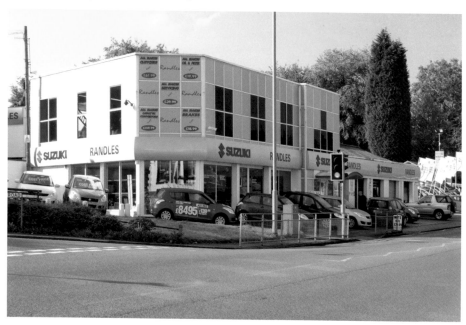

Deansgate and Drayton Road, Higherland, Late 1920s

The old photograph is taken from Deansgate, where Burke's car showroom stands in the previous photograph. The men are posing at the bottom of the present Seabridge Road, previously called Drayton Road because, until Priory Road was created in the late 1920s, this road formed part of the main route to Whitmore and Market Drayton. Next to the Sneyd Arms, opposite, is Drayton Street, no longer a real street and only accessible from Higherland via several steps.

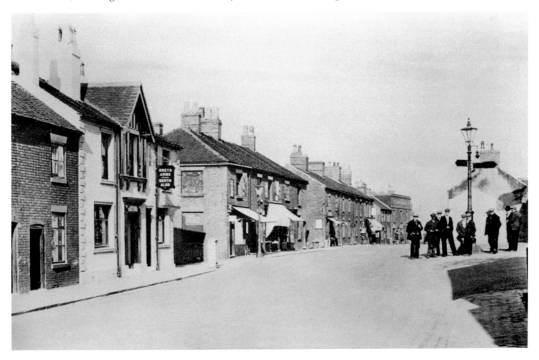

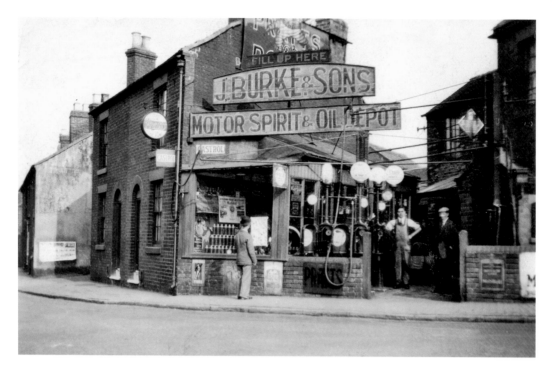

Higherland, J. T. Burke's Motor Spirit & Oil Depot, 1920s

Opposite the Sneyd Arms, at the bottom of Drayton Road (now Seabridge Road), stood J. T. Burke's 'filling station'. Here William Edward Burke stands next to the pumps. The business was formerly Burke's saddlery but Burke was clearly an entrepreneur who could see in which direction the future of transport lay. Today Burke's house and business are long gone although the modern picture shows a filling station on the site where the Burke family was to build their later premises.

Wrinehill, The Lord Nelson, 1930s

This Lord Nelson pub was situated in Wrinehill, on a site later occupied by a car-sales business and now destined for housing. Country pubs were already diversifying even in the 1930s because the Nelson not only advertises Alsopp's and Ind Coope ales but also Teas and Hovis. This road is now wider and busier although the cottages to the left remain little altered. On the hill stands the 'Summer House' built *c.* 1710 by the Egerton family of Wrinehill Hall.

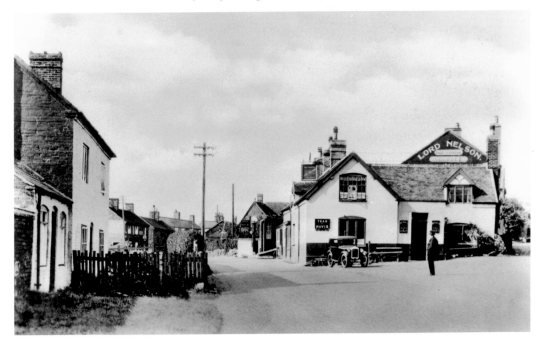

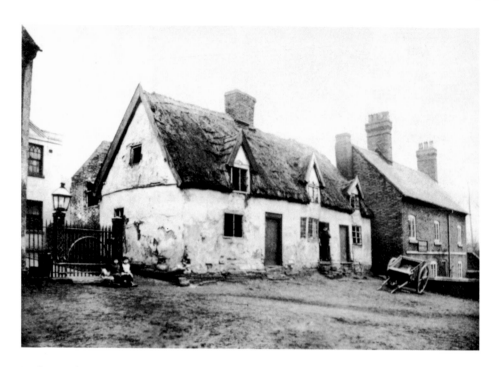

Betley, Main Road, Old Cottages, 1870s

Heading through Betley towards Newcastle the road passes where these ancient cottages and the Methodist chapel behind them used to stand. The 'new' houses that replaced these cottages, and which still stand there today, were built by Thomas Fletcher Twemlow in 1880 and bear his initials. The old chapel was demolished relatively recently but sadly was not photographed before the process began. The replacement chapel can be seen in the recent photograph although that has now been converted to flats.

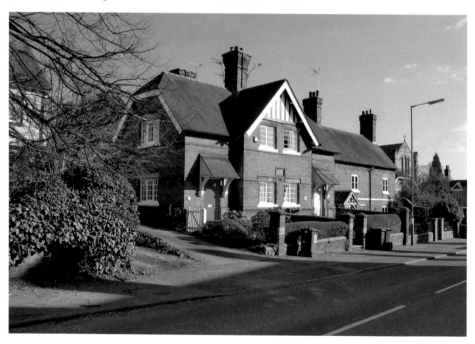

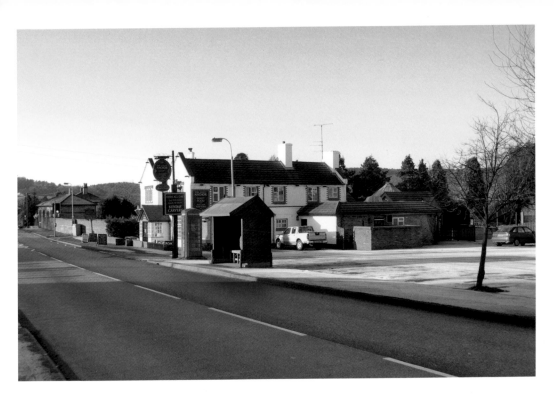

Baldwins Gate Art Deco Filling Station, 1930s

A filling station may not normally be thought of as an exciting subject but this state-of the-art Art Deco structure at Baldwins Gate bears no resemblance to modern filling stations, except in that it was possible to fill up in the rain without getting wet. Although the rather attractive filling station is long gone, the Sheet Anchor pub, the roadside Baldwins Gate station building and the stationmaster's house beyond can all still be seen in the more recent photograph.

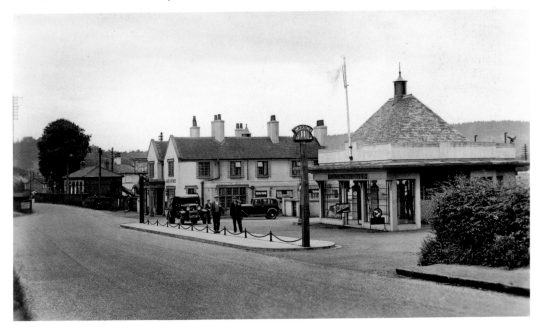

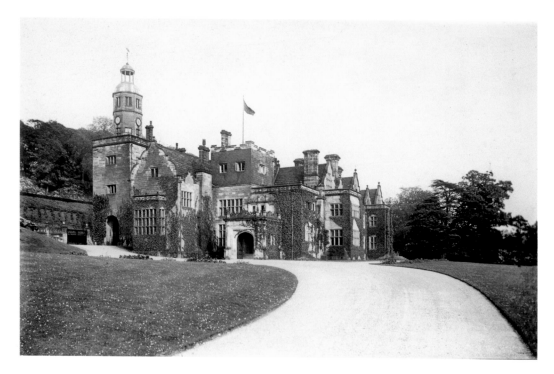

Maer, Maer Hall

Maer Hall has undergone a remarkable cycle of alterations, as documented in these photographs, and deserves an entire book to itself. The main sepia image shows the house after extensions to the west end by Liverpool shipping magnate, Frederick Harrison. The house had already been enlarged by the Davenport family (see inset) but grew considerably under Harrison. In the 1960s Dr Tellwright removed the leaky extensions and restored the house to how it was when Josiah Wedgwood II lived there.

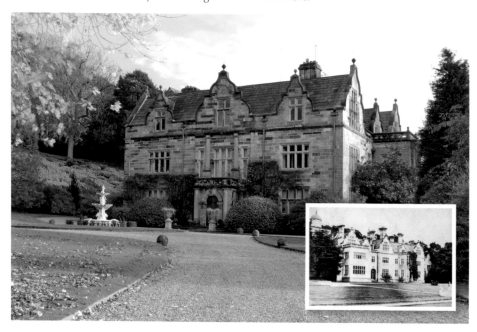

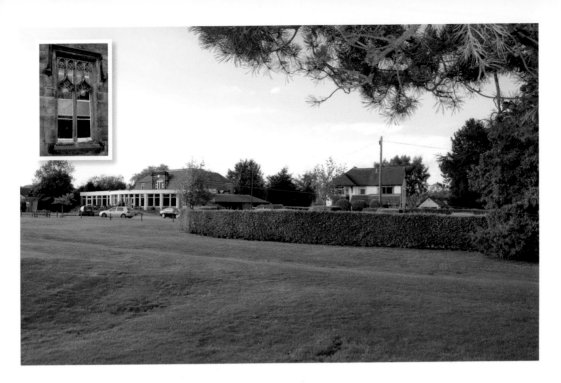

The Westlands, Newcastle Golf Club Clubhouse, *c.* 1940
Newcastle Golf Club was founded in 1908 and the *c.* 1940 photograph shows the corrugated-iron clubhouse of the day. Behind and to the left is a small but nevertheless rather grandiose private house. This house, now the clubhouse, owed its grandeur to having been put together using masonry salvaged from Sir William Pilkington's magnificent Butterton Hall, completed in 1850 but demolished in 1924. The modern photograph shows the clubhouse vastly altered, with the inset showing a surviving Butterton Hall window.

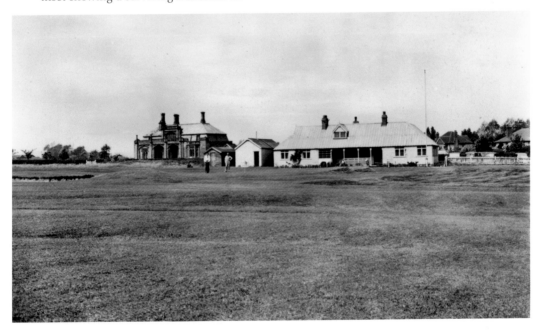

73

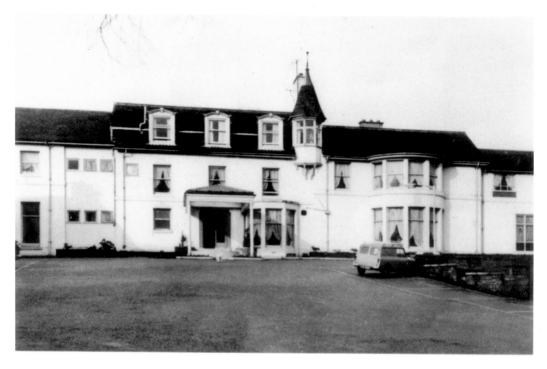

Clayton, Clayton Lodge, c. 1967

Built c. 1800 as a gentleman's residence, Clayton Lodge was enlarged by G. H. Downing the tile-works' owner. Mr Downing funded the building of a new North Staffs Royal Infirmary x-ray department, but sadly died in 1937 almost to the day that the Downing Wing was officially opened. In 1951 the house was sold and converted into the Clayton Lodge Hotel. The modern photograph shows clearly the 1969 wing that was unsympathetically grafted on to the front of the fine old house.

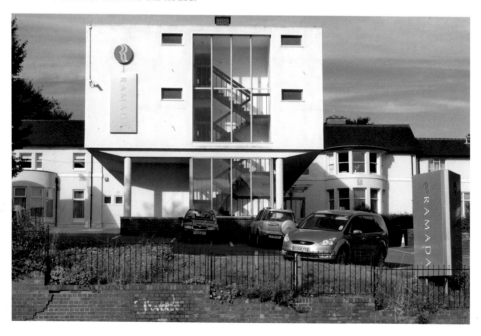

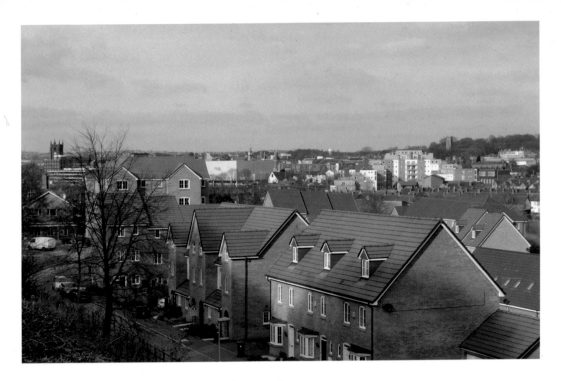

Clayton Road, View Over Newcastle Town Centre, 1979
Clayton 'bank', as locals know it, offers an extensive view over Newcastle town centre. By 1970 Newcastle had already undergone massive changes during the previous twenty-five years. In the new photograph, the ancient town centre has been encircled by tall new buildings. The foreground is filled by houses and apartment-blocks, the gasworks, and Castle House have gone and Morston House, Sainsbury's, the Vue Cinema and No. 1 London Road, looking rather like a child's Lego model, have arrived.

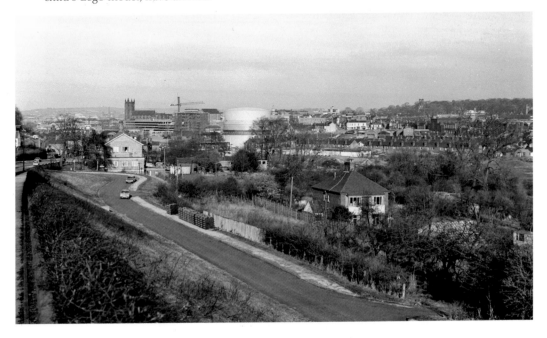

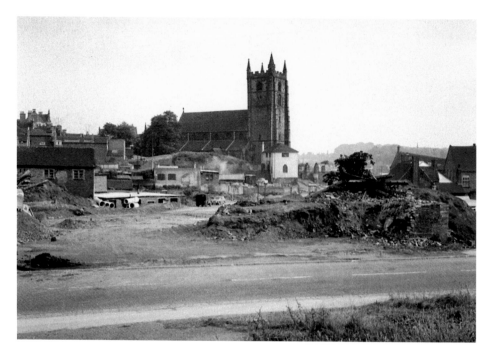

Upper Green, Holborn and the A34, 1964

The road running across this 1964 photograph is Upper Green and the brickwork to the right is probably the last remnants of the Almshouses. The buildings to the right of the rubble, the Dog & Partridge and the Paper Mill were situated in Holborn. As can be seen from the modern photograph, this entire area is now dominated by the A34. The large white Unitarian Meeting House still survives, as does the former Bridge Street Arts Centre on the left.

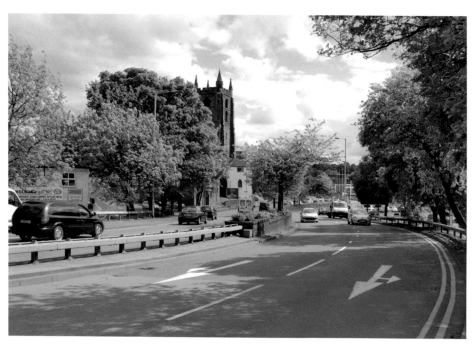

Holborn, Early 1960s

This early 1960s photograph was taken from outside the Dog & Partridge pub in Holborn. Between the 'modern' buildings beyond the pub is Holborn's junction with Lower Green to the left and Upper Green to the right. Younger Newcastilians will be totally unfamiliar with these lost street names. The Dog has been gone for many years but the later buildings still stand, overlooking the busy A34 dual carriageway. They have now been joined by a Travelodge perched above a small supermarket.

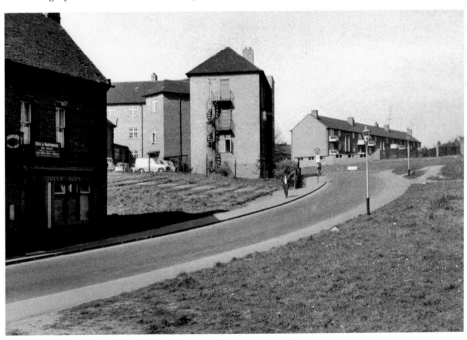

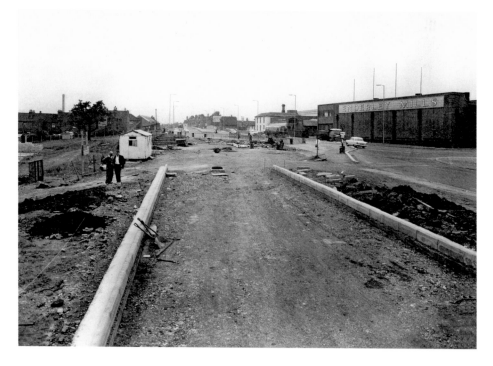

Liverpool Road/A34 Dual Carriageway Northbound, 1960s

This 1960s photograph shows the northbound A34 dual carriageway under construction. On the right is Liverpool Road, and then two large buildings, both demolished in the 1980s: Enderley Mills, where military uniforms were made, and a large white mansion outside the PMT bus garage. This house was The Beeches, home to William Mellard, ironmonger and Newcastle's Mayor on three occasions. The bus depot itself remains and a large Sainsbury's supermarket has now been built to the left of the modern view.

Liverpool Road, the Old Milehouse Inn, *c.* 1910

On Liverpool Road, a mile from the centre of Newcastle stood the Milehouse Inn; built 1813, demolished 1932. In this early photograph the licensee, Thomas Brayford, and his family, their horse and cart, the pub cat and even possibly the resident entertainers (the man in the straw boater is holding a banjo) are shown posing outside the pub. To the left is Milehouse Lane. In today's rather different scene a plaque (see inset) shows where the pub used to stand.

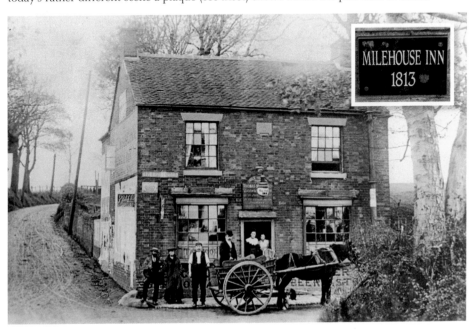

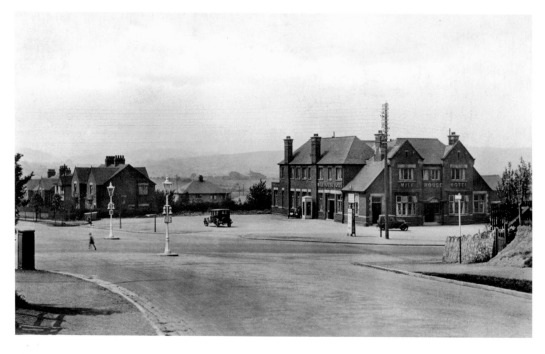

Liverpool Road, the 'New' Milehouse Hotel, Late 1930s

In its 1932 incarnation the Milehouse Hotel was certainly a much larger and grander establishment than the old Milehouse Inn. Photographed from Milehouse Lane, the hotel is only a few years old here and looks out over a deserted crossroads. For many years the establishment went by the name of the Berni Inn and is now Buffet Island, a Chinese restaurant. The crossroads is now yet another roundabout which is only ever quiet in the early hours of the morning.

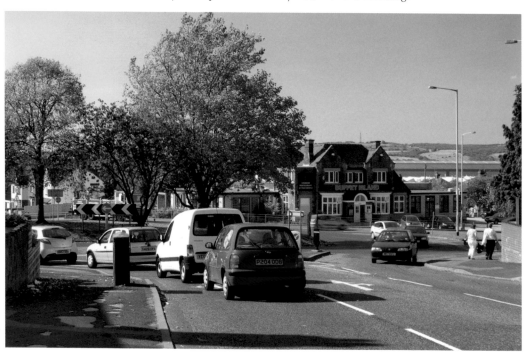

Chesterton, The Hollows, 1950s

Chesterton Garage, like many buildings in this volume, has now been replaced by a traffic island. The virtual shantytown of bungalows running up the hill has been replaced by better-quality housing and the Fanny Deakin Maternity Hospital, visible at the top, has also been demolished. Fanny Deakin was a Local and later County Councillor who was remarkable in that she was voted into office repeatedly despite being an openly declared communist, for which she earned the epithet 'Red Fanny'.

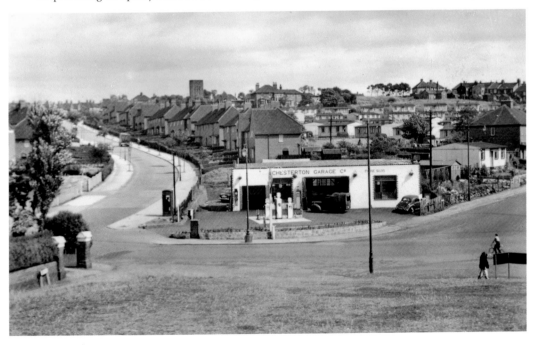

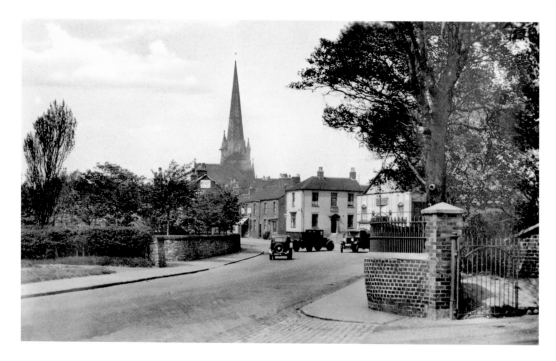

Wolstanton from The Marsh, *c.* 1940

This *c.* 1940 photograph shows an empty 'lorry' entering the Wolstanton 'pit' road and another emerging filled with coal. Beyond the mine road stands the Marshlands Cinema known by local children as the 'bug hut'. Beyond that is the Archer public house, now renamed the New Smithy, still standing despite strenuous efforts to have it demolished in order to enlarge the St Wulstans Catholic church car park. Presiding over the scene is St Margaret's church, originally serving a parish extending to Mow Cop.

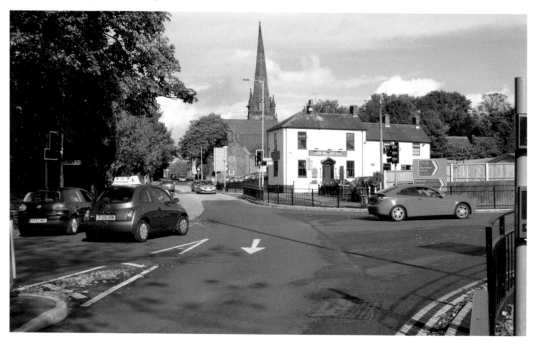

Wolstanton War Memorial, *c.* 1940

Outside St Margaret's lychgate is a war memorial dedicated on 21 November 1920. A recent book, *Call to War*, tells the stories of those commemorated. The buildings between Chetwynd Street and Wedgwood Street survive, but all those beyond have been demolished including no fewer than three pubs, the Plough Inn, The Royal Oak and the Jolly Potters on the corner of Wedgwood Street. The original Morris Square was replaced by the modern version, set back from the road.

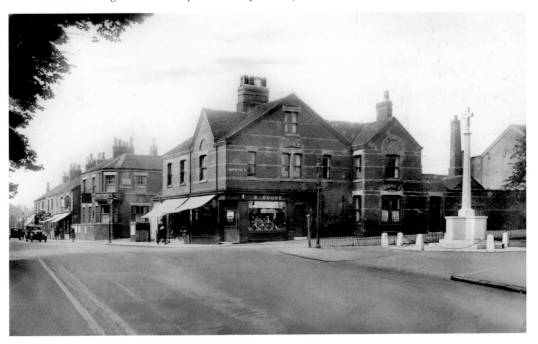

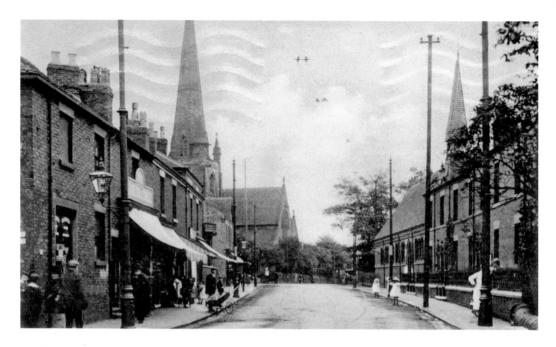

Wolstanton, St Margaret's Church, *c.* 1915

As so many times in this volume, precise replication of an old photograph is positively dangerous. In the old photograph it was the pavements that were busy, whereas today it is the road; there are few seconds now when there is not at least one vehicle passing over this spot. The person on the left in the modern image would just have passed the Jolly Potters visible in the *c.* 1915 photograph. The spire on the old school has been removed.

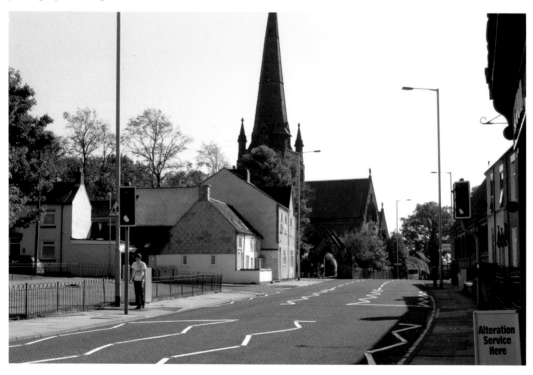

Wolstanton, Junction of Lily Street and High Street, *c.* 1910

Whilst Wolstanton still largely manages to retain a village character, the closure of its shops and pubs is undesirable because it forces residents to go further afield for their needs. Interestingly the nearest shop on the *c.* 1910 photograph is the London Central Meat Co. which had branches all over England; was this perhaps an early example of a franchise? Beyond the shops stands high status housing with the grandest properties, including Watlands House and its lodge, situated on the left.

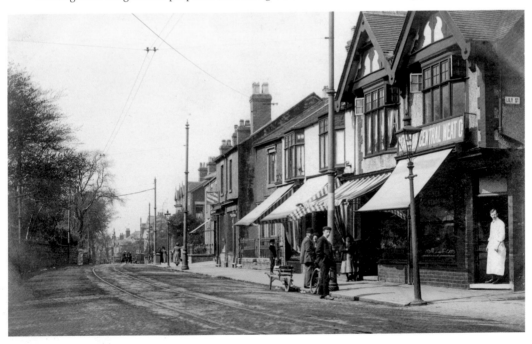

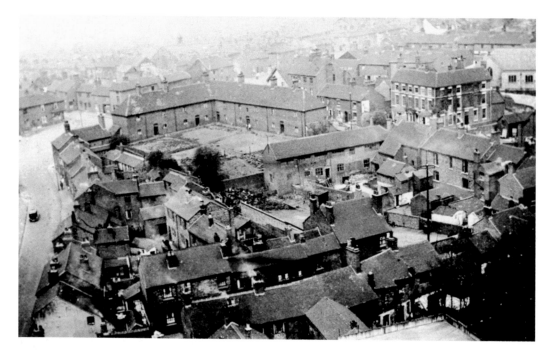

Bridge Street from St Giles' Church Tower, 1930s

The 110 feet high, St Giles' church tower provides a perfect vantage point over Newcastle town centre and its environs. This 1930s image shows Froghall in the foreground, Bridge Street to the right, and the junction of Upper Green, Lower Green and Holborn next to the 'L' shaped Albemarle Almshouses. These streets of insanitary terraced housing have largely disappeared today with the only buildings present on both photographs being the Old Brown Jug pub and its neighbours in Bridge Street.

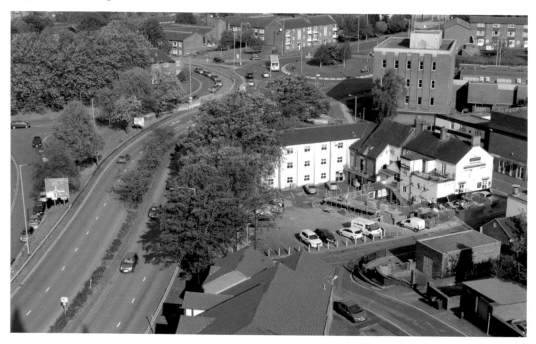

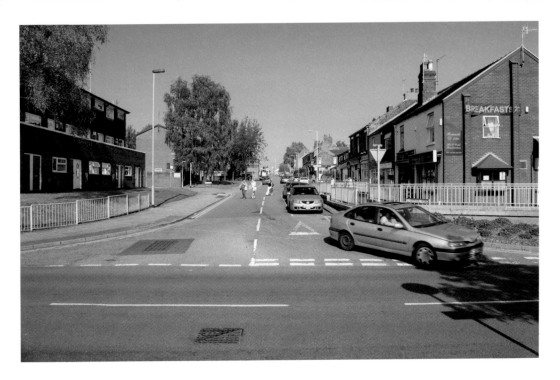

Liverpool Road, St John's Church, 1920s

The 1920s view shows what a busy thoroughfare Liverpool Road used to be when traffic passed through Newcastle via London Road, High Street and Liverpool Road. On the left is St John's Church, which appears at the right-hand edge of the previous old photograph. On the right is the arched entry to the garden/outside studio of Mr Edwin Harrison who had moved here from the buildings on page 24. Harrison took many of the earliest views of Newcastle included here.

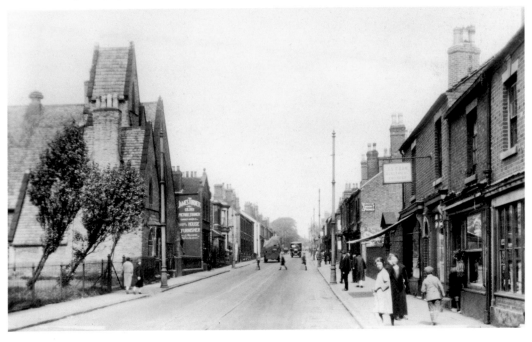

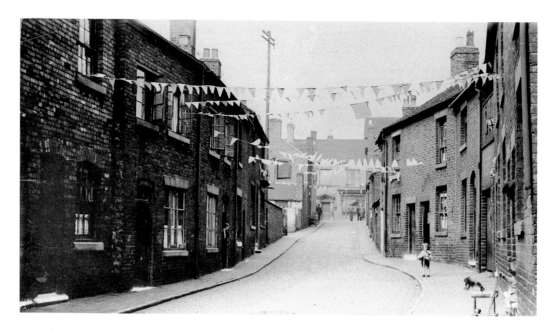

Froghall, 1935/36

The bunting commemorates either the Silver Jubilee of George V in 1935 or the Coronation of George VI in 1936. Fewer photographs were taken of Newcastle's poorer streets than of the main streets so this one of Froghall is quite unusual. The pub on Bridge Street is the Old Vine Inn. The photographer's position can easily be worked out from the photograph showing Froghall from St Giles' tower. Froghall still exists but is now just an access road to modern commercial premises.

Bridge Street and the Albemarle Almshouses, 1960s

The 1960s view shows the full length of Bridge Street to its junction with Liverpool Road. On the right are the Albemarle Almshouses built in 1743 to house twenty poor widows of the Borough. This L-shaped building had a garden at the rear where the residents could relax together. In the distance is the tall Pearson's building in Red Lion Square. Cars are parked outside the Old Brown Jug, now the only survivor of several original Bridge Street pubs.

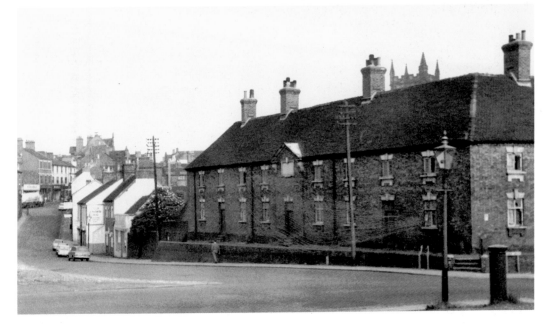

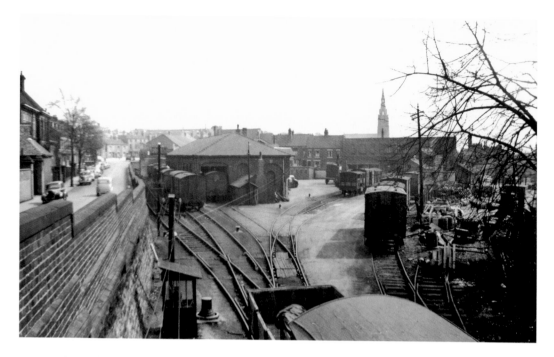

Newcastle Station Goods Yard and Water Street, 1940s

To the left runs Water Street, originally Waterloo Street, following the route of Newcastle's 'upper canal'. Behind the photographer is Newcastle station with its goods line running on one side of the Borough Arms and the passenger line on the other. The scene today would be unrecognisable were it not for some distinctive buildings in Water Street. In the distance, some of the Brunswick Street terraces survive but are largely obscured, as is St Paul's Church in Victoria Road.

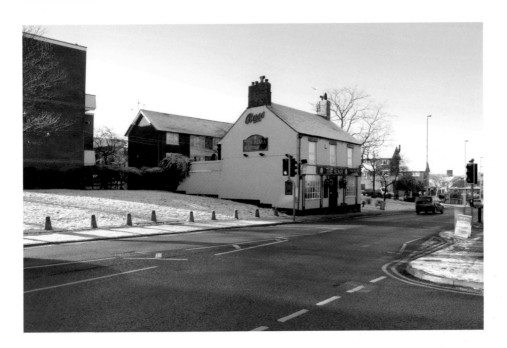

George Street, The Alma, *c.* 1957

Shops used to extend up Brunswick Street and George Street to Hartshill. Today, of the row shown in the old photograph only The Alma public house survives. S. T. Chadwick's radio supplies shop, situated on the opposite corner of Lockwood Street from the Alma, moved across the road when these buildings were demolished and survived there into the 1980s. James Stone & Sons Ltd, fishmongers, still operate from Stubbs Street, one of very few long-established Newcastle family businesses to survive.

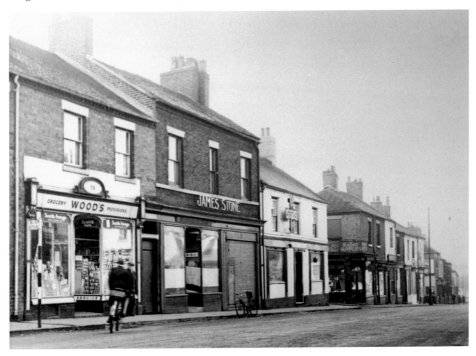

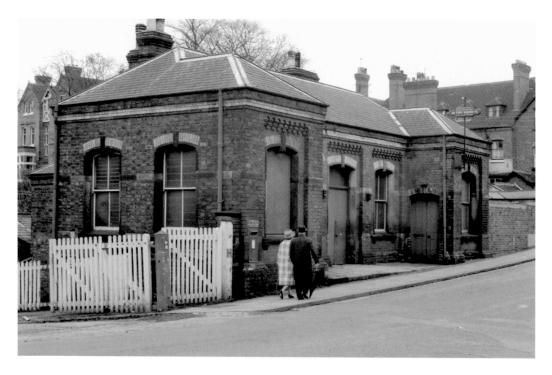

King Street, Newcastle Railway Station, 1960s

Heading from Newcastle towards Hanley would take you past Newcastle railway station, which was on the Stoke-on-Trent to Market Drayton line. In this 1960s photograph the station has been closed, courtesy of Dr Beeching, and is awaiting demolition. From this building a covered walkway led to the Up platform. On the left side of the building a road allowed goods vehicles to the Down platform to load and unload. Now the platforms and track-beds are buried and grassed over.

Newcastle Railway Station and the Borough Arms Hotel, 1960s
This photograph is possibly unique showing the station building from the rear and in the background the Borough Arms Hotel, no longer benefitting from rail passengers alighting at the station. The sloping roof at the rear covers the steps to the Down platform, the buildings on the left being situated on that platform. Before the railway arrived in 1852 a canal ran through here to Water Street, terminating at Stubbs Walks. Now the Borough Arms gazes out over 'Station Walks'.

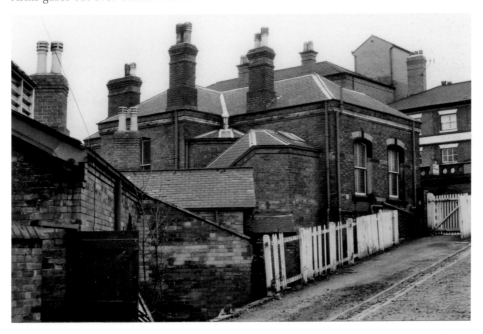

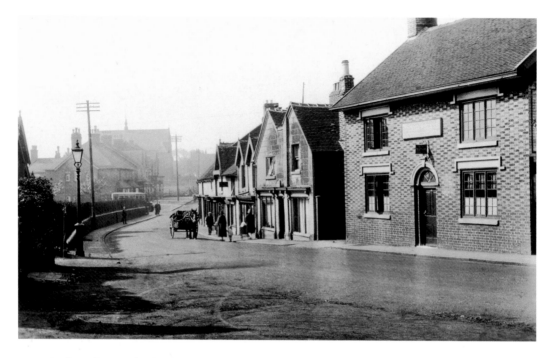

Audley, The Butcher's Arms, *c.* 1915

This photograph taken from by Audley's, St James the Less parish church, shows the Butchers Arms public house in the foreground, a series of seventeenth-century timber-framed houses beyond it and, in the distance, Audley Primitive Methodist Chapel. In the modern picture, the Butchers Arms has been rebuilt as an unconvincing mock-Tudor structure and the Methodist chapel has gone. Fortunately the old houses remain relatively untouched by progress. On the left behind the bus stands Thomas Warham's photography business.

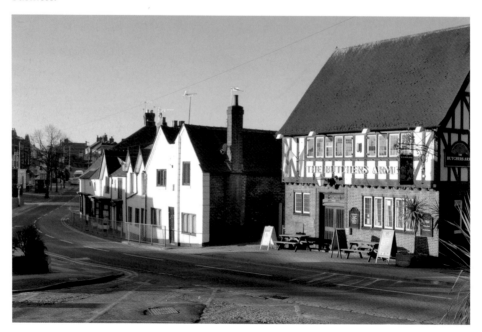